Turner and the Whale

About the authors

Meg Boulton is a freelance lecturer of Art History and a research affiliate at the University of York, whose wider research addresses the conceptualisation and representation of space, with interests crossing the Medieval to the post-modern.

Martha Cattell is a collaborative PhD student with the History of Art Department, University of York, and the Hull Maritime Museum, whose work explores the visual and material cultures of the 19th-century whaling industry.

Jason Edwards is a Professor of Art History at the University of York, who works on the global contexts of British art history across the long nineteenth century, and at the intersections of queer and vegan theory.

Turner and the Whale

Jason Edwards, ed.

Supported by
The National Lottery®
through the Heritage Lottery Fund

heritage
lottery fund

Working in partnership

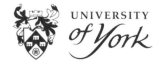
UNIVERSITY
of York

Shire Publications, an imprint of Osprey Publishing Ltd
c/o Bloomsbury Publishing Plc
PO Box 883, Oxford, OX1 9PL, UK

E-mail: shire@shirebooks.co.uk
www.shirebooks.co.uk

SHIRE is a trademark of Osprey Publishing Ltd, a division of Bloomsbury Publishing Plc.
First published in Great Britain in 2017

A CIP catalogue record for this book is available from the British Library.

ISBN: PB: 978 1 78442 285 1
 ePub: 978 1 78442 286 8
 ePDF: 978 1 78442 287 5
 XML: 978 1 78442 288 2

17 18 19 20 21 10 9 8 7 6 5 4 3 2 1

Jason Edwards, Martha Cattell and Meg Boulton have asserted their right under the Copyright, Designs and Patents Act, 1988, to be identified as the authors of this book.

Typeset in Adobe Garamond Pro
Origination by PDQ Media, Bungay, UK
Printed in China through World Print Ltd

Shire Publications supports the Woodland Trust, the UK's leading woodland conservation charity. Between 2014 and 2018 our donations are being spent on their Centenary Woods project in the UK.

Front cover image: *Whalers (Boiling Blubber) Entangled in Flaw Ice, Endeavouring to Extricate Themselves* (*c*.1846), oil on canvas, 89.9. x 120 cm. Accepted by the nation as part of the Turner Bequest, 1856. © Tate, London (N000547)

Contents

Acknowledgements

We are grateful to the Arts and Humanities Research Council for the Collaborative Doctoral Award that enabled much of the research underpinning this project, and to the staff at the Hull Maritime Museum, especially Robin Diaper, for his ongoing enthusiasm, expertise and support.

We are thankful to our colleagues in York Art History Collaborations and the British Art Research School in the History of Art department at the University of York, and especially the School's director, Richard Johns, the co-curator, with Christine Riding, of the 2013–14 *Turner and the Sea* exhibition.

We are indebted to everyone at the Paul Mellon Centre for Studies in British Art, the Yale Center for British Art, and the New Bedford Whaling Museum, for their enthusiastic reception of this project, and for their generous doctoral research fellowships, which enabled much of the research underpinning this project.

We are also grateful to our colleagues at Tate Britain, especially Amy Concannon, for giving us access to crucial works by Turner.

We are thankful to our colleagues at the Metropolitan Museum of Art for their *Turner's Whaling Pictures* exhibition, and to Robert K. Wallace, to whom all scholars in this field are indebted.

Finally, we would like to thank the Heritage Lottery Fund without whose funding this project would not be possible.

We dedicate our work to the billions of fish, birds and mammals needlessly killed each year for human food.

Martha Cattell and Jason Edwards
University of York, Winter 2016–17

Chapter 1

Introduction:
Turner and the Whale

Jason Edwards

HULL, CAPITAL OF WHALING CULTURE

Hull's museums and their collections have long been on the map for those interested in the history of whaling. In 'A Bower in the Arsacides', Chapter 102 of Herman Melville's seminal whaling novel *Moby-Dick* (1851), the narrator describes a 'Leviathanic Museum' in Hull, 'one of the whaling ports of that country, where they have some fine specimens of fin-backs and other whales'.[1] This museum was the Museum of Hull's Literary and Philosophical Society, which was founded in 1822, and opened its first exhibition in 1827 – a diverse collection of artefacts that resembled a museum-sized cabinet of curiosities, containing numerous natural historical and anthropological exhibits relating to the city's whaling industry.[2]

The public display of Hull's maritime collections got a significant boost in 1912 when the Museum of Fisheries and Shipping, the successor, in many ways, to the

earlier Literary and Philosophical Society Museum, opened in Pickering Park. By the 1970s, however, the collections had outgrown even these premises, and the old Dock Office in the city centre became available as a new home for them in 1975, when the building was renamed the Hull Maritime Museum, although it is still fondly recalled by some residents as the Town Docks Museum.

The former Dock Office, a recognisable landmark in the city, with its distinctive triangular shape and three iconic domes, was designed by Christopher G. Wray, and built between 1868 and 1871, at the time Hull's whaling industry was drawing to a close. It was originally home to the Hull Dock Company, which managed the city's port operations, and the building is decorated with maritime motifs, including anchors, fishing nets, and tridents, making it the ideal architectural frame for the new museum and this exhibition. In addition, as the former Dock Office, the building, like the exhibition and permanent collections it now houses, is a symbol of Hull's significant maritime history; a reminder of the period during which ships sailed up to the museum's doors and passed through the city centre for everyone to see.[3]

The Hull Maritime Museum is one of the most significant repositories of maritime objects in the UK outside of the National Maritime Museum in Greenwich. The museum houses collections relating to the fishing trade, docks and docking, merchant shipping, ship building, navigation, inland waterways, general maritime history, and whaling. It includes a large archive of photographs, prints and books, a sizeable collection of marine art, and one of the largest collections of scrimshaw – carving on whale and walrus bone – anywhere outside of the United States.[4]

The collections are divided into three main categories – whaling, fishing and the merchant trade – and concentrate on Hull's maritime activities from the late eighteenth

century to the present. The permanent displays relating to whaling cover the entire ground floor and include a range of journals, maps, logbooks, try-works, harpoons and other whaling tools; numerous canvases from the local Hull School of painters; as well as the scrimshaw, and collections of Inuit visual and material culture.

TURNER AND THE WHALE

Turner and the Whale brings to the museum and to Hull, the capital of the nineteenth-century British whaling industry, for the first time from Tate Britain, home of the Turner Bequest of more than 30,000 images, Turner's three late whaling oils: *Whalers* (1845), *Hurrah! for the Whaler Erebus! Another Fish!* (1846), and *Whalers (Boiling Blubber) Entangled in Flaw, and Trying to Extricate Themselves* (1846) alongside a full-scale reproduction of a second 1845 canvas, *Whalers*, now housed in the Metropolitan Museum of Art in New York.[5] These were first shown in pairs at the Royal Academy summer exhibitions in 1845–46.

The exhibition uniquely contextualises Turner's whaling pictures with a range of images and objects from Tate and Hull Maritime Museum, which testify to the painter's lifelong interest in marine and maritime life, and to Hull's centrality to the long-nineteenth-century Arctic whaling industry.[6] For example, from the Tate's collection comes Turner's closely related *Stormy Sea with Dolphins* (*c.*1845), whilst the Hull Maritime Museum collections provide four key elements. The first is the scrimshaw collection (see chapter 4); these folk sculptures often depict portraits of whale ships and scenes of whaling, carved by the whalers themselves on pieces of whalebone and sperm whale teeth, and they were brought home by the whalers as souvenirs and gifts for loved ones.

The second element consists of the natural historical specimens brought back to the UK from the Arctic, including complete skeletons of whales and a polar bear, as well as other pieces of Arctic osteology. These were collected, mostly dead, but sometimes alive, partly as objects of curiosity, and partly to 'draw attention to the commercial value of the sea mammals' hunted by Hull sailors.[7] Living animals were destined for Hull's Zoological Gardens, which first opened in 1840, and dead specimens, in the form of skeletons, skins, or taxidermy, for the Literary and Philosophical Museum. These included the skeletons of various kinds of whales and narwhals; a stuffed polar bear; and an Arctic fox and hare brought back from the region by famed Arctic explorer Sir John Ross. Ross donated them in recognition of the key role played by the city's whaler, the *Isabella*, in his 1833 rescue from Lancaster Sound, after he was stranded in the north, where he was missing, presumed dead, for four Arctic winters.

The third element of the display, the significant examples of Inuit carvings (see chapter 5), show, to some extent, the different indigenous understandings and representations of polar hunting, including whales. A number of these were brought to the city by the Inuit themselves, or back to Hull by whalers and explorers, and they were almost certainly made with them in mind. For example, as Arthur G. Credland and Robert G. David have documented, Britain witnessed the arrival of numerous travellers from the polar circle, especially around the middle of the century, at around the time when Turner was working on his four *Whalers*.

For instance, in the winter of 1847–48, the *Hull Advertiser* drew the locals' attention to Memiaduluk and Uckaluk, two teenaged Inuit from Nyatlick, in the Cumberland Sound in the north of Canada. These so-called 'specimen[s] of the tribes

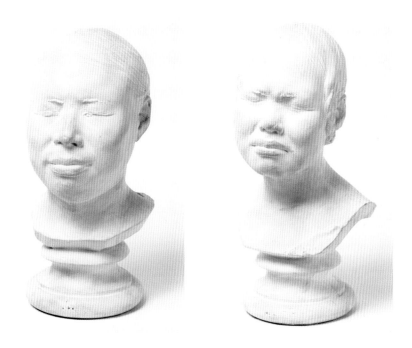

Fig. 1.1 and **fig. 1.2** W.D. Keyworth, *Memiaduluk* and *Uckaluk* (*c*.1847–48), plaster. © Hull Maritime Museum (KINCM:2007.1450.1=2)

of the far North' had recently arrived on the whaler *Truelove,* and would be toured, by whaling captain John Parker, to York, Manchester, Beverley and Driffield, where they were seen by some 12,000 people in their 'native costume' and accompanied by a 'canoe, hut, bows and arrows'.[8] The ghosts of the two remain in the museum in the form of a pair of poignant life-cast busts fashioned in plaster by local sculptor William Keyworth; Uckaluk died on her journey home after becoming infected with measles when their boat docked at Orkney (see figs 1.1 and 1.2).

In 1850, Hull was again visited, this time by an Inuit man who arrived in a whaling ship, and who delighted locals with his nautical exploits, before drowning. His kayak was preserved in the Museum of the Literary and Philosophical Society before being transferred to the Hull Maritime Museum, where it joined another example of a kayak, which was again donated to the museum by Ross.[9] Three further Inuits, 'Tickalicktoo', 'Harbah' and 'Harkalukjoe' – an 18-year-old man, a 16-year-old girl, and a seven-year-old boy – could be found in the city between 1853 and 1855. They also visited York, Pocklington and Windsor Castle, where they met Queen Victoria, and their movements were tracked in the national papers, including the *Illustrated London News.*[10]

Such travellers, from Greenland and the Eastern Canadian Arctic, frequently brought indigenous artefacts with them, which ended up in the Literary and Philosophical Society Museum. These small, relatively easily transported, and often bartered or 'trucked' items included examples of tools, weapons, 'toys' and tents, as well as clothes, including boots, snow shoes and snow spectacles. Images and objects relating to hunting and fishing – such as bone hooks and sealskin lines – along with those relating to shamanistic ceremonies – such as masks – tended to dominate, and Inuit artisans increasingly capitalised on what was effectively a market for tourist

Fig. 1.3 John Ward, *The 'Swan' and 'Isabella'* (*c*.1830), 50 x 69 cm. © Hull Maritime Museum (KINCM:2007.1442)

souvenirs among the whalers, running a local cottage industry that manufactured models of boats, houses, tents and igloos, complete with sledges drawn by dogs.[11]

Finally, the exhibition brings Turner's whale quartet (see chapter 3) into close relationship, for the first time, with a range of important canvases, much loved by locals but little known beyond the region, from the Hull School of marine painters (see chapter 2); these are primarily concerned with the city's Arctic whaling trade. During the nineteenth century, Hull was not only the centre of Arctic whaling in the UK, but also the only whaling port that had its own distinct group of local artists; painters whose works were in such regional demand that they were rarely seen in London. Of especial significance within this group was the unjustly neglected regional painter John Ward. Initially a house- and ship-portrait painter and sign writer, Ward was the only artist amongst the Hull School whose later work was shown at the Royal Academy in London in 1840. It was there that Turner would have seen his 'Swan' and 'Isabella' (see fig. 1.3), which perhaps inspired Turner's own later whaling works; this canvas is shown alongside Turner's *Whalers* for the first time in this exhibition.

We might also, however, draw attention to the possible relationship between Turner's Tate *Whalers*, in particular, and a canvas by the little-known Newcastle marine painter John Wilson Carmichael. Whilst there is no archival evidence to suggest that Turner saw the picture, and the degree to which the two artists resolve their canvases down to detail is different, there is a suggestive resemblance between the Tate *Whalers* and Carmichael's *Newcastle Whaling Fleet in the Arctic* (c.1835), now in the New Bedford Whaling Museum (see fig. 1.4). This is particularly apparent in the shared positioning of the spouting whale close to the low horizon line on the extreme right; of the white sails of the ship behind it on the horizon; and of the foreshortened

Fig. 1.4 John Wilson Carmichael, *Newcastle Whaling Fleet in the Arctic* (c.1835), oil on canvas, 106.7 x 160 cm. © New Bedford Whaling Museum (2001.100.4713)

whaleboat coming into the picture at an angle, in Carmichael's case, on the lower left of his canvas, and, in Turner's, in the centre of his picture. Turner may well have known Carmichael's work, since he was a regular exhibitor at the Royal Academy, from 1835 to his death in 1868. In 1845, Carmichael showed two pictures alongside Turner's *Whalers*, and Carmichael's *Nelson and the Deal Boatmen* was likely to have attracted Turner's attention since it depicted one of his favourite coastal resorts.[12]

Traditionally, regional canvases by artists such as Ward or Carmichael have come off as the poor provincial cousins of Turner's metropolitan and cosmopolitan genius. For example, the 2013 solo exhibition *Turner and the Sea,* which travelled from the National Maritime Museum to the Peabody Essex Museum in Salem, Massachusetts, epitomised the view of Turner as the most significant of British marine painters of any period. The 2016 exhibition *Spreading Canvas: Eighteenth-Century British Marine Painting*, at the Yale Center for British Art, meanwhile, sought to explore the tradition that emerged between the Van de Veldes and Turner, and to recover what viewers, before Turner's 'radical reconsideration of the sea' and 'reinvention of marine painting', 'expected and understood from marine paintings'. The show nevertheless acknowledged the way in which, for most spectators, Turner's predecessors and peers continued to be 'found wanting in comparison'.[13]

However, as David has noted, whilst there were numerous marine artists in Hull, and in Britain more generally in the nineteenth century, none apart from Ward 'seems to have had first-hand knowledge of the Arctic'. According to an urban myth circulating in the period and since, he accompanied a whaling ship to the Arctic in 1823, with the '*Swan' and 'Isabella'*, the canvas seen by Turner at the Royal Academy in 1840, 'clearly benefitting from his first hand knowledge'.[14] Though Ward was

supposedly unique amongst his peers, for having visited the Arctic, many of the canvases of his Hull colleagues were, according to David, largely 'painted for ship owners' and thus 'rarely seen by the public', and exhibited 'considerable understanding of Arctic scenery', presumably the 'result of local knowledge' and detailed discussions between patrons and painters regarding the precise details of the forms of the ships themselves and of the whaling industries in which they were deeply invested. Indeed if, as David claims, their 'limitations as artists' were 'more to do with technique', resulting in some 'grotesque interpretations of ice features and fauna', they knew more than Turner who has seemed, to many maritime specialists, to have 'indiscriminately mixed' Arctic and Antarctic whaling scenes.[15]

In bringing together the aforementioned images and objects, *Turner and the Whale* intervenes in four current debates. It contributes to the increasingly sophisticated scholarship on long-nineteenth-century British marine painting, and makes a contribution to Turner studies in particular, arguing that the painter's 1840s' seascapes reveal a new ethical complexity.[16] The exhibition also provides a key art-historical evidence base to challenge the dominant literary-historical accounts of nineteenth-century Anglo-American whaling and polar exploration.[17] In addition, *Turner and the Whale* returns scrimshaw to a nineteenth-century sculpture studies increasingly alive to the importance of amateur craft traditions, thanks to the recent development of a sophisticated new field of folk art and interdisciplinary craft studies.[18] Finally, the exhibition contributes to a new, again fast-growing, interdisciplinary critical animal studies, just finding its feet in art history, raising questions about the ethics of whaling, fishing, and other forms of animal consumption and marine imagery in the nineteenth century and beyond.[19]

TURNER AND THE WHALE, 2017

At the time of writing, the circum-Polar world has, perhaps, never been more in the news. For our nineteenth-century predecessors, even those whalers who regularly went to the Arctic, the polar landscape must have seemed a world away. However, as we now know, our relationship to the Arctic is closer than any of our Victorian predecessors could have known, whilst whale populations, alongside dozens of other species, continue to be threatened with extinction. As meat consumption is estimated to double by 2050, contributing to the continual rise in global carbon dioxide levels and the subsequent temperature increase, the melting of polar ice into the sea will transform the shape of coastlines around the world, including our own. Indeed, according to contemporary philosopher Cary Wolfe, 'all around us' a historically unprecedented 'Holocaust' against our 'fellow creatures', that makes nineteenth-century whaling seem like child's play, 'rages on and indeed accelerates'.[20]

Writing in 1820, famed Whitby whaling captain William Scoresby junior wondered whether the changes he observed in the position of the ice on his successive voyages to the Arctic were 'partial or permanent'. He was confident that whether the overall ice was in the 'course of diminishing or enlarging', overall a 'balance of power' would be 'preserved between the wasting influence of the waves and the solidity and increasing property of the polar ice; the former preventing the undue enlargement of the boundaries of the ice, and the latter defying any extensive, or at least permanent, inroads into the situations usually occupied by it'. Indeed, Scoresby believed, the 'equilibrium between the quantity of new ice produced and of old ice destroyed' was 'so well preserved, that the absolute quantity of ice in the polar seas is always nearly the same', and was certainly 'restored in the course of a few years'. In addition, whilst

beginning to notice the way in which there was a 'dependent chain of animal life', such that if 'one particular link' were 'destroyed, the whole must certainly perish', Scoresby remained confident that the 'immensity of creation' and the 'profusion of life' on earth would continue unabated.[21] We might be able to factory farm animals in the billions to torture and kill each year, but when it comes to the overall ecosystem in which we all find ourselves, we can no longer afford to be so confident or morally complacent.

ENDNOTES

1 Herman Melville, *Moby-Dick* (1851; Oxford: Oxford University Press, 1988), 402.

2 For more, see the anonymous *Guide to the Museum of the Literary and Philosophical Society, Hull* (Hull, 1860).

3 For more on the history of Hull as a whaling port, see Arthur G. Credland, *The Hull Whaling Trade: An Arctic Enterprise* (Hull: Hutton, 1995); and on the history of British whaling, George Jackson, *The British Whaling Trade* (London: Adam and Charles Black, 1978).

4 For more on the scrimshaw, see Janet West and Arthur G. Credland, *Scrimshaw: The Art of the Whaler* (London: Hutton, 1995); and on the Hull School of Marine Art, Arthur G. Credland, *Marine Painting in Hull through Three Centuries* (Hull: Hutton/Cull City Museums and Art Galleries, 1993). For more on scrimshaw generally, see Stuart M. Frank, *Ingenious Contrivances, Curiously Carved: Scrimshaw in the New Bedford Whaling Museum* (Boston: David R. Godine, 2012).

5 For more on the history of the Turner Bequest, see Sam Smiles, *J.M.W. Turner: The Making of a Modern Artist* (Manchester: Manchester University Press, 2007).

6 For more on Turner's lifelong interest in marine and maritime life, see Christine Riding and Richard Johns, eds, *Turner and the Sea* (London: Thames and Hudson, 2013).

7 Robert G. David, *The Arctic in the British Imagination, 1818–1914* (Manchester: Manchester University Press, 2000), 172.

8 Credland, *The Hull Whaling Trade,* 70, 89; David, *The Arctic in the British Imagination,* 133–137.

9 David, *The Arctic in the British Imagination*, 145.

10 Credland, *The Arctic Whaling Trade*, 90.

11 For more, see David, *The Arctic in the British Imagination*, 130, 132–134, 141–143, 145. For more on shamanistic culture, and its accompanying objects, see Patricia Rieff Anawalt, *Shamanic Regalia in the Far North* (London: Thames and Hudson, 2014).

12 Carmichael exhibited at the Royal Academy in 1835, 1841, 1843, 1845, and annually from 1847 to 1859. For more on Carmichael's exhibition history at the Royal Academy, see Algernon Graves, *The Royal Academy of Arts: A Complete Dictionary of Contributors and Their Work from its Foundation in 1769 to 1904* (New York: Franklin, 1970), 1: 395–397. For more on Carmichael, see Diana Villar, *John Wilson Carmichael 1799–1868* (Portsmouth: Carmichael and Sweet, 1995); and Andrew Greg, *John Wilson Carmichael 1799–1868* (Tyne and Wear: Tyne and Wear Museums, 1999).

13 Eleanor Hughes, ed., *Spreading Canvas: Eighteenth-Century British Marine Painting* (New Haven: Yale University Press, 2016), 4, 85, 181. The catalogue acknowledges its metropolitan bias, noting its focus on the 'maritime-metropolitan nexus' and on 'painting in London rather than the rich traditions that flourished in other maritime centers', such as Bristol, Liverpool, and Hull (8). Barry Venning similarly argues that 'Turner's whaling series was far more ambitious than anything produced by the Hull school; for he sought to embrace the whaling industry as a whole by treating the Pacific fishery in 1845 and its Arctic counterpart in the following year' ('Turner's Whaling Subjects', *Burlington Magazine* 127 (February 1985), 75–83; 76). Venning also argues that whilst Hull painter Thomas Binks's *The 'Viewforth', 'Middleton', and 'Jane' Beset in the Ice* 'is a far less accomplished performance' than Turner's, 'that is not to belittle the sentiments it would have aroused' (79).

14 David, *The Arctic in the British Imagination*, 164. For more on Ward, see *John Ward of Hull: Marine Painter, 1798–1849* (Hull: Ferens Art Gallery, 1981). The *Swan* was first used as a whaler in 1824, continuing in that profession until 1840. It had earlier been the ship on which Sir John Ross attempted a North-West Passage in 1818.

15 David, *The Arctic in the British Imagination*, 182.

16 For recent readings of the British marine painting tradition, see Geoff Quilley, *Empire to Nation: Art, History and the Visualisation of Maritime Britain, 1768–1829* (New Haven: Yale University Press, 2011); and Sarah Monks, 'Suffer a Sea Change: Turner, Painting, Drowning', *Tate Papers* 14 (2010) (http://www.tate.org.uk/research/publications/tate-papers/14/suffer-a-sea-change-turner-painting-drowning); and 'Turner Goes Dutch', in David Solkin, ed., *Turner and the Masters* (London: Tate, 2009), 73–85.

17 In addition to *Moby-Dick,* some of the key literary texts include Samuel Taylor Coleridge's *The Rime of the Ancient Mariner* (1798); Mary Shelley's *Frankenstein* (1818); Edgar Allen Poe's *The Narrative of Arthur Gordon Pym of Nantucket* (1838); Charles Dickens and Wilkie Collins's *The Frozen Deep* (1857); Elizabeth Gaskell's *Sylvia's Lovers* (1863); and Charlotte Bronte's *Jane Eyre* (1847 – but composed in 1846, the year Turner's second pair of whalers was displayed at the Royal Academy). The key art-historical works, when it comes to thinking about the nineteenth-century poles, meanwhile, are taken to be Casper David Friedrich's *The Wreck of the Hope* (1824); Frederic Church's *The Voyage of the Icebergs* (1860); and Edwin Landseer's *Man Proposes, God Disposes* (1865).

18 For examples, see Ruth Kenny, Jeff McMillan, and Martin Myrone, *British Folk Art* (London: Tate, 2014); and Glenn Adamson, *The Invention of Craft* (London: Bloomsbury, 2013).

19 For representative examples, see Carol J. Adams, *The Sexual Politics of Meat: A Feminist-Vegetarian Critical Theory* (New York: Continuum, 1990); Jacques Derrida, *The Animal That Therefore I Am* (Ashland: Fordham University Press, 2008); Donna J. Haraway, *Where Species Meet* (Minneapolis: University of Minnesota Press, 2008); Bruno LaTour, *Reassembing the Social: An Introduction to Actor-Network-Theory* (Oxford: Oxford University Press, 2005); and Cary Wolfe, *Animal Rites: American Culture, The Discourse of Species, and Posthumanist Theory* (Chicago: University of Chicago Press, 2003), and *Before the Law: Humans and Other Animals in a Biopolitical Frame* (Chicago: University of Chicago Press, 2013).

20 Wolfe, *Before the Law*, 104.

21 William Scoresby junior, *An Account of the Arctic Regions, with a History and Description of the Northern Whale Fishery* (Edinburgh: Archibald and Constable, 1820), I: 179–180, 263, 285, 305, 321.

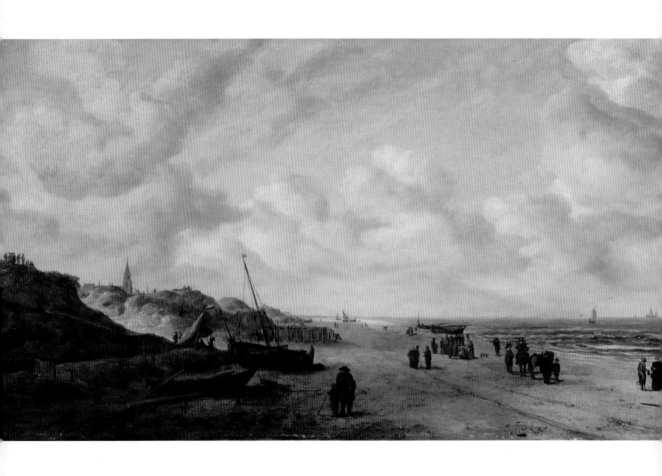

24

Chapter 2
The Hull School of Whale Painting

Martha Cattell

INTRODUCTION: WHALING AND ART HISTORY

View of Scheveningen Sands (*c.*1641) by Dutch marine painter Hendrick van Anthonissen (see fig. 2.1) was donated to the Fitzwilliam Museum, Cambridge, in 1873. Van Anthonissen's work takes, as its subject, the Flemish coastal town of Scheveningen. The scene depicts a mellow littoral landscape, where the slowly lapping waves of the North Sea are shown breaking lightly against the shoreline. A series of masts and sails visible on the far horizon, and a number of wooden boats on the sands,

Fig. 2.1 Hendrick van Anthonissen, *View of Scheveningen Sands* (c.1641), before restoration, oil on canvas, 56.8 x 102.8 cm. © Fitzwilliam Museum, Cambridge

indicate the rich maritime culture of the local residents and the wider Dutch nation, which, at the time of the painting's creation, was experiencing a golden age.[1] To the left of the composition the local church tower rises from between the dunes, reaching into the vast expanse of cloud that hangs over the coastal scene, its prominent ascension adding a religious overtone to the scene. The sands are populated by an array of humans and animals including a horse and dog. The people are a mix of classes, genders and ages, and seemingly pause to talk to one another, or gaze at the landscape that stretches before them. A man leads a small child down the beach, whilst a one-legged beggar pauses in front of an aristocratic couple, and distant figures cluster on the dunes on the crisp winter's day.

What was, however, a routine conservation effort of the painting in 2014 altered the composition, and the removal of a covering layer of resin exposed a large beached sperm whale in the shallows of the scene (see fig. 2.2).[2] The effect of the whale's body, which had previously lain concealed for over 150 years, gives a new agency to the narrative focus of the work; one which is animal-centred and for which an altered title now reads *View of Scheveningen Sands, with a Stranded Sperm Whale*. The groups of human figures now gather to observe the whale, pointing at its vast bulk, and joining together to discuss its appearance on the sands. The rendition of the whale is comparatively crude, lying in a seemingly placid state with the hint of a smile; a contrast to the flaccid, deflated reality of such situations in real life.

After the whale's re-appearance, the canvas was subsequently rehung in the Dutch Golden Age gallery of the Fitzwilliam, entrenching the work within a fine art context that promotes a rhetoric of human capitalist success. Its reappearance also creates a scene that now portrays a dying or possibly dead whale, displaced from its typical

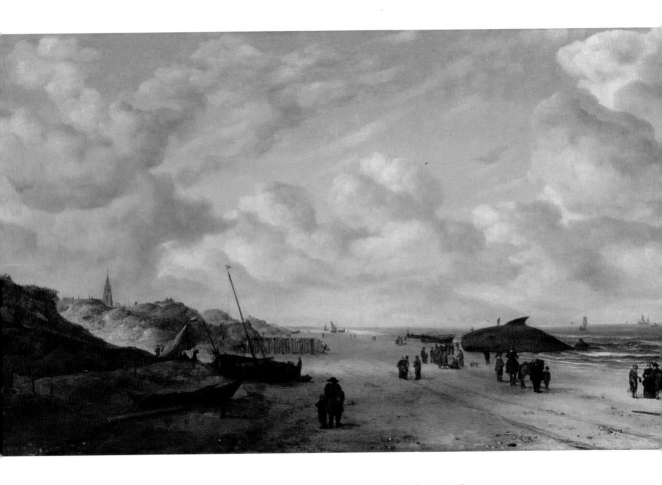

Fig. 2.2 Hendrick van Anthonissen, *View of Scheveningen Sands* (*c*.1641), after restoration, oil on canvas, 56.8 x 102.8 cm. © Fitzwilliam Museum, Cambridge

geography into a new spatial realm. Animals in this space of human dominion are domesticated (as represented by the dogs and horses) or rendered consumable objects (as suggested by the fishing boats). Through the disappearance of the whale from the image until conservation, the picture points to the anxieties and fascinations that have persisted in relation to whales, and to the destabilising effect certain animals can have on human society.[3] Despite drawing attention to the uncovering of the whale, its revelation should not, however, be read as a spectacular re-insertion of whales into art history. Far from it, even if its reappearance and the subsequent press attention suggest the novelty that animal bodies and specifically whales can still possess.

After all, Van Anthonissen's painting is not alone in depicting a whale. For, as Julie Urbanik notes, 'economic systems support and shape human use of animals', and the growth of the Western commercial whaling industry in the polar regions and south seas from the sixteenth century repeatedly framed whales as objects of human interest and for human use.[4] As a result, whales subsequently became a more prominent feature in visual and material culture, particularly in areas where the industry flourished such as the Netherlands, Britain, and the eastern seaboard of the United States. For British whaling in particular, the long nineteenth century, and specifically the period between *c*.1783 and *c*.1830, represented a high point for the trade; a commercial prosperity complemented by a series of images and objects that ranged widely in form, media, creator and intended audience.[5] Examples included popular prints, depicting the whaling process, and taxonomic illustrations of different whale species; a vast array of paintings by regional artists, such as John Ward and John Wilson Carmichael; a famous quartet by J.M.W. Turner, and an accompanying series of watercolour sketches.[6]

A further, less well known, but arguably no less interesting, series of paintings were created by the 'Hull School' of artists, who operated from the whaling port.[7] Prominent members, alongside John Ward, included Robert Willoughby, William Griffin, James Wheldon and Thomas Binks.[8] Whilst the label of the Hull School was not in use in the period, it is a useful term for a distinct artistic style that grew out of the northern city that was built on the success of its maritime trade, and included new docks, which opened in 1829. Although these artists did not solely focus on whaling subjects, it is these works that are here of interest, the majority of which are now housed in the collections of the Hull Maritime Museum; the Ferens Art Gallery, in Hull; and across the Atlantic, in the New Bedford Whaling Museum, Massachusetts, and in the National Gallery of Art, Washington, D.C.[9]

To date, metropolitan art historians have not paid much attention to the whaling works created by the Hull School, although there has been a wealth of local scholarship, including, most prominently, a number of introductory publications by former Keeper of the Hull Maritime Museum, Arthur G. Credland, and a couple of exhibitions in Hull on the subject.[10] Indeed, the Hull School have been largely absent from more recent, sophisticated scholarship on marine painting, where the work of local painters has been dismissed as a 'stylistically unadventurous and narrowly patronized genre', or overshadowed by more famous nineteenth-century marine painters, most noticeably Turner.[11] The artists do feature as entries in marine painting dictionaries, yet little room is given over to critical readings of their work.[12] This is perhaps surprising since the work of the Hull School is not just relevant to maritime historians, but to those working in critical animal studies. In the remainder of this essay, I begin by emphasising the wider nexus within which the Hull School were operative, outlining the rich

tapestry of influences they drew from, and commented upon, including Arctic explorations and the whaling trade. I then move on to give close visual analyses of a number of works to demonstrate the more ethical framework through which such works need to be approached today.

THE HULL SCHOOL, c.1796–1869

Apprenticeships formed the typical training for whaling marine artists in Hull, who were largely operative during the years c.1796–1869, the dates ranging from when the first known whaling marine painting was done, by a Hull painter, to when the last Hull whaler, the *Diana*, was wrecked, homeward bound off the Lincolnshire coast.[13] Lasting around seven years, approximately the same length as the time a metropolitan painter would spend training at the Royal Academy, the apprenticed painters would learn utilitarian skills, including ship, house, and sign painting, with fine art often having to be practised in their spare time.[14]

There has been much speculation over whether any artists from the Hull School went to the Arctic, with some suggestion that Ward did, yet there is little surviving archival evidence to support these claims.[15] Thomas Fletcher, who was credited with creating one of the earliest examples of a whaling marine painting to come out of Hull, '*Molly' and Friends* (1787) (see fig. 2.3), dominated the apprenticeship trade in the eighteenth century, and is presumed to have acted as tutor to Willoughby.[16]

Fig. 2.3 Thomas Fletcher, '*Molly' and Friends* (1787), oil on canvas, 95.8 x 135 cm.
© Hull Maritime Museum (KINCM:2007.1315)

The foreground of Fletcher's painting is darkened, which leads the eye to the illuminated middle ground, where three whaleboats tow a large whale to the ship *Molly*, which is characteristically shown twice, in stern-quarter and profile view, with *Friends* also in stern-quarter view in the middle distance. The monogram 'AS', visible on the whaleboats, is indicative of the commissioning of the painting by local whaling captain Angus Sadler. A noticeable characteristic of this work, and other Hull School canvases, is the mellowness of the human encounter with whales, and stylistic ties to wider depictions of hunting, which would often present it in more gentle terms, with the hunters stripped of their violent ruthlessness, as was the case with many imperial activities.[17] For example, in 1844, the year in which Turner's first *Whalers* went on display at the Royal Academy, the Second Secretary at the Admiralty, John Barrow, making no mention of local indigenous populations, whose livelihoods would be threatened, declared that the Arctic was 'well deserving the attention of a power like England', and that if England failed to search for a north-west passage to India, she 'would be laughed at by all the world'.[18]

In the nineteenth century, Meggitt and Sons replaced Fletcher's role as the most prominent source of apprenticeships, overseeing a number of marine painters, including Ward, Griffin and Binks.[19] This shared training amongst the artists often resulted in a similarity in styles, and, at times, attribution of works has proven problematic, suggesting that, when it came to the Hull School, the fame of the artist was less important to local

Fig. 2.4 Abraham Storck, *Whaling Grounds in the Arctic Ocean* (1654–1708), oil on canvas, 50.5 × 66.5cm. © Rijksmuseum, Amsterdam (SK-A-4102)

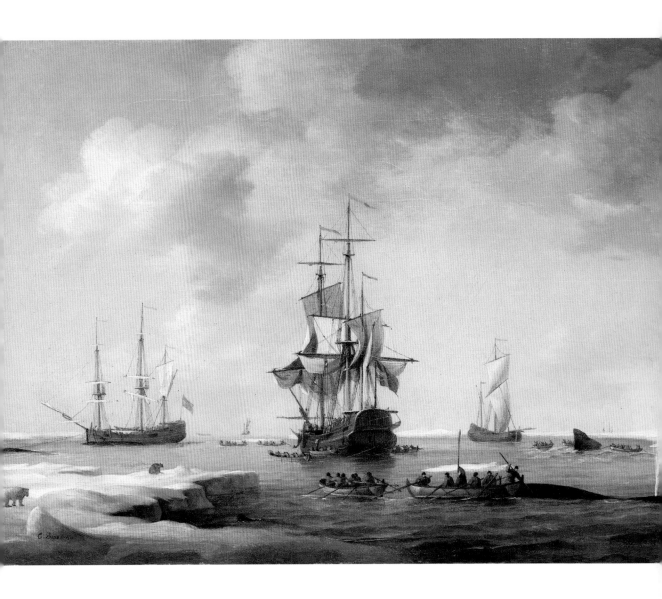

34

patrons than the accuracy of the ships and scenes depicted. Behind these turn-of-the-nineteenth-century apprenticeships, marine painting, much like the Arctic whaling trade in Britain, had a strong Dutch legacy, with the former often attributed to the influence of the father and son emigres, the Van de Veldes, who established a marine painting studio in Greenwich after coming to England from Amsterdam *c.*1672, during which time they worked under the patronage of Charles II, and provided a source of inspiration for a string of marine painters in Britain.[20] One of Willem van de Velde II's works, *The Four Day Battle, 1666* (seventeenth century) can be seen in the collections of the Ferens Art Gallery. The Van de Veldes appear not to have done any paintings of whaling, but it is a subject addressed by other Dutch marine painters such as Abraham Storck (1654–1708) in his work *Whaling Grounds in the Arctic Ocean* (seventeenth century); one of his paintings, *Ships of the River*, was owned by Turner.[21]

Storck's painting (see fig. 2.4) shows three Dutch whalers in the various stages of whaling, from making the kill – visible in the mid-centre of the work, where a harpoon sticks out of the back of a whale, as the lead harpooner holds aloft a further weapon aiming to penetrate its vital organs – to flensing, shown behind this, where strips of blubber are visibly pulled aboard the vessel. In various places, the scene is populated with an array of native fauna, in the form of polar bears, walruses and birds. Icebergs loom in the right rear of the composition, and a portentous grey sky hangs over the scene. Storck also depicts a number of vessels in the background close to the ice, one

Fig. 2.5 Charles Brooking, *Greenland Fishery: English Whalers in the Ice* (c.1750), oil on canvas, 29.3 x 43 cm. © National Maritime Museum, London (BHC1035)

visible at the foot of a large iceberg, and, in so doing, suggests the dangers of the trade, such as being trapped in ice floes or crushed by icebergs, but, with his patrons' confidence and commercial interests in mind, Storck noticeably reduces the possible threat of the ice in comparison with the large central vessels.

Despite the local success of the Hull School painters, however, the assumed arbiter of national artistic taste, the Royal Academy, characterised marine painting as less important than other, more significant genres, such as history painting.[22] This did not stop marine painting developing a sizeable market and popularity throughout the course of the eighteenth and nineteenth centuries, both in London and in a number of regional centres, including Hull, Newcastle, Bristol and Norwich. The genre circulated in various guises, from prints and pub signs, to appearing as tattoo subjects and carved on the surface of whalebone by whalers in the form of scrimshaw (see chapter 4).[23]

Though the Hull School are often absent, or reduced to footnotes, in contemporary marine painting studies, the painters themselves had a wide knowledge of the genre they were depicting, in terms of the practices of whaling, the habits of maritime life, and each other's works. This knowledge was vital if they were to gain commissions, as when translating into paint depictions of nautical elements, such as rigging and whalers' clothing, accuracy was crucial. Like many of their peers, the Hull School painters probably turned to Dutch sources to help them fashion their works, either in the form of original canvases or similar derivative imagery, which was disseminated in Britain in printed form.[24] For example, Charles Brooking's *Greenland Fishery: English Whalers in the Ice* (*c*.1750) (see fig. 2.5), was evidently inspired by Dutch prints, and exists in at least three painted versions, one of which was in the collections of Trinity House in Hull, during the time in which the Hull School were active (*c*.1750–1860).

Fig. 2.6 John Ward, *Whalers in the Arctic* (19th century), 47 x 65 cm, oil on canvas.
© Hull Maritime Museum (KINCM:2009.1124)

The ice floes in Brooking's canvas probably inspired the similar ones in the foreground of Ward's *Whalers in the Arctic* (nineteenth century) (see fig. 2.6).

Marine painter to King William IV, William Huggins was also an inspiration. After spending his early life at sea, Huggins created a number of whaling works including *Northern Whale Fishery* (1829), which was later adapted as a print by Edward Duncan and copied in Wheldon's *Hull Whaler 'Harmony' (After William John Huggins)* (date unknown) (see fig. 2.7).[25] This shows the whale ship *Harmony*, amongst others, catching and killing whales in the Davis Straits. Huggins's animals were particularly influential; his seals, walruses and narwhals reappear almost verbatim in a number of paintings by Ward and Wheldon, suggesting how few people in Britain had seen such animals at the time.

The whaling paintings created by the Hull School would often follow the trajectory and successes of the whaling trade; for example, early works were filled with scenes of prosperity. Some of these works, such as William Griffin's *Whaleship 'Mary Frances'* (1832), appear more simple in their composition, with the vessel in Griffin's painting being shown in three views – bow, profile and stern-quarter – afloat on a choppy sea (see fig. 2.8). The canvas was likely commissioned to celebrate the successful whaling season of 1832 for the master of the ship, William Couldrey, whose boat caught 29 whales.[26] The buoyant ship, here, acts as an extension of Couldrey, proudly navigating and whaling in the distant waters.

Willoughby's *'Aurora'* (c.1803–17) (see fig. 2.9) is more complex, with the incorporation of an Arctic setting and the process of whaling. A dead whale dominates the centre of the composition. It has recently met its death at the hands of the *Aurora's* crew, who busy themselves extracting the precious blubber and bone from its now

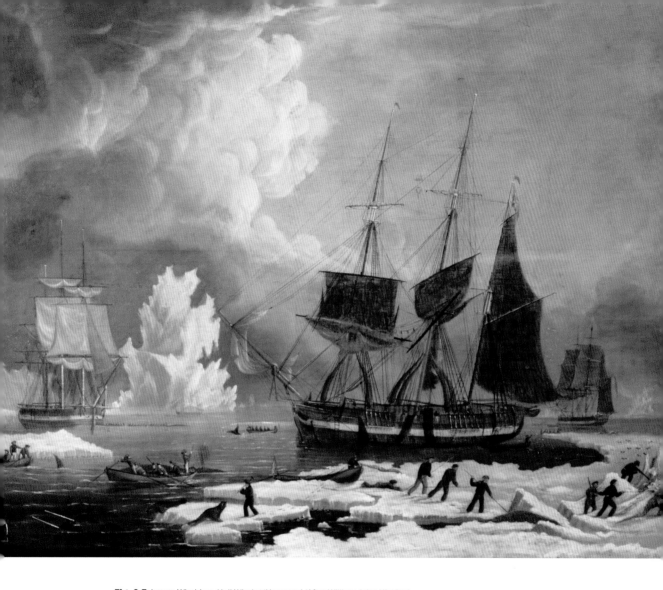

Fig. 2.7 James Wheldon, *Hull Whaler 'Harmony' (After William John Higgins)*
(date unknown), oil on canvas, 94 x 124 cm. © Hull Maritime Museum (KINCM:2007.1441)

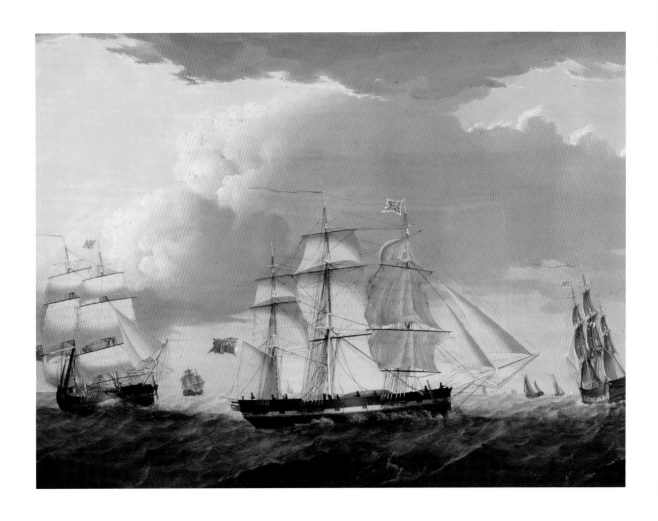

Fig. 2.8 William Griffin, *Whaleship 'Mary Frances'* (1832), oil on canvas, 61 x 99 cm.
© Hull Maritime Museum (KINCM:2007.1157)

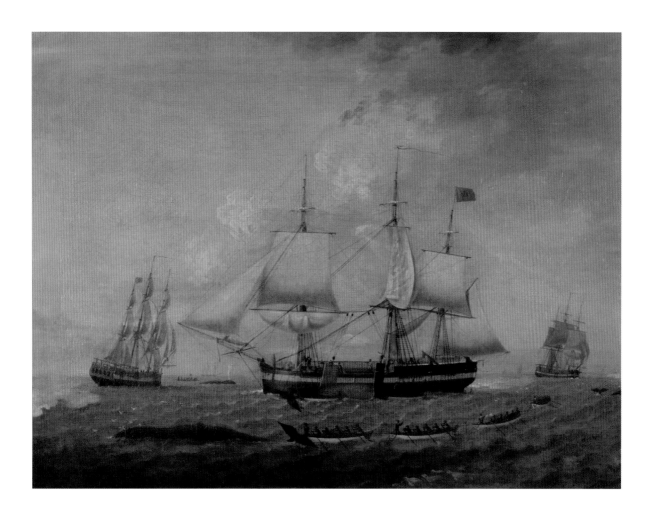

Fig. 2.9 Robert Willoughby, *'Aurora'* (19th century), oil on canvas, 70 x 101 cm.
© Hull Maritime Museum (KINCM:2007.1535)

flaccid body. Its black, lifeless form is stretched and secured alongside the barque, as slips of whale blubber are winched aboard the vessel via a series of speck tackles (large hooks), hanging suspended between the fore and main masts. The painting freeze frames the flensing process at a point that is not just revelatory in terms of the whaler's bounty, but one that visually strips the whale's identity back to its economic worth. Through this central detail, viewers' eyes are drawn in to the scene, implicating them in the killing and processing, as they are encouraged to dissect visually the whale as an object, observing its value as constitute parts, and further hunting the fecund scene for more animals, shown here in the form of whale flukes and backs located in the background of the painting. This ultimately creates a scene of invasion of both the whale's body and also Arctic space more generally, which, through a carefully constructed compositional narrative, implicates the viewer and the process of viewing.

This detail, of the whale flukes, can be found replicated across Hull School paintings. It can also be found in whaling logbooks (see fig. 2.10), which were used by the captains of whale ships to record information including the local weather conditions, latitude, and whale kills; the last would be signalled by a stamp that would typically be in the shape of a whale fluke (see fig. 2.11). Therefore, each time it appears in a Hull School canvas, a whale fluke suggests the death of the whale in question and the clear victory of the whalers.

Fig. 2.10 (above) Joseph Taylor, the logbook of the whaler *Swan* for a voyage to the Davis Straits, March–August 1817 (1817), ink on paper, 32 x 40 cm. © Hull Maritime Museum (KINCM:2007.1494)

Fig. 2.11 (below) Wooden whale stamp, 7.5 x 3.5 cm. © Hull Maritime Museum (KINCM:2007.1493)

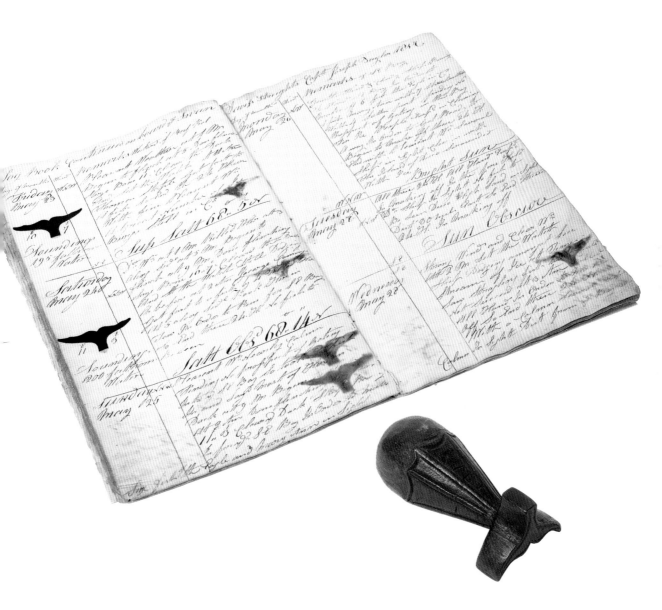

Ward's *'Swan' and 'Isabella'* offers a similar example (see fig. 2.12). Ward is, by far, the most lauded of the Hull School artists, thanks to a superiority of detail in his work, and because he gained acclaim outside his native city, through exhibiting at the Royal Academy and British Institution. For example, as we have seen, the *'Swan' and 'Isabella'* was exhibited at the Royal Academy in 1840, and has been cited as a key source of inspiration for Turner's whaling paintings, since Turner was on the Royal Academy hanging committee in 1840, and, therefore, must have seen the picture.[27]

Ward finished a number of works based on the two ships, the *Swan* and *Isabella,* building on the success of the *Isabella*'s rescue, in 1833, of Arctic explorer John Ross, whose boat had become trapped in the ice.[28] The version in the Hull Maritime Museum collection could have been the one displayed at the Royal Academy or, as suggested elsewhere, might be a study for a larger version currently held at Hull Trinity House.[29] In the Hull Museum version, ice floes in the right foreground lead the eye in towards the *Isabella,* where large blubber pieces are visible. On board the barque a number of whale jawbones hang down from the distinctive green masts; a clear suggestion of an already successful season for the crew. The main mast also supports a crow's nest, located at the top. This rotund structure was created by famed Whitby whaling captain, William Scoresby senior, in order to give protection when surveying the Arctic landscape.[30]

Ward's picture does not just include whales being hunted, but also polar bears. Polar bears, or 'bruins' as they were popularly known by whalers, were renowned for their ferocity, but were often killed or brought back to Hull as curiosities. For example, a zoological garden, which opened in the city in 1840, housed a polar bear. This would have offered the chance for artists, as well as residents, to see Arctic fauna

Fig. 2.12 John Ward, The *'Swan' and 'Isabella'* (c.1830), oil on canvas, 33 x 51 cm.
© Hull Maritime Museum (KINCM:2005.2315)

first-hand, although few local artists successfully captured the form of this creature. In Ward's canvas, the brutality of the trade is characteristically reduced, and a distinct lack of animality is shown in the whales and polar bears, which would more often react, quite naturally, with violence. For example, William Scoresby junior's influential 1820 narrative *An Account of the Arctic Regions, with a History and Description of the Northern Whale Fishery* documented how sometimes the whales threw themselves into a 'perpendicular posture, with their heads downwards, and rear[ed] their tails on high in the air, beat[ing] the water with awful violence'.[31] Ward's typically ordered composition shows no such resistance from whales, and violence is minimised in order to suggest a confident, prosperous masculinity instead, to flatter a circle of patrons consisting mostly of whale ship owners and the captains of whalers.[32]

Whaling was, however, a risky, declining business in the first half of the nineteenth century, and, as we have seen, from the 1830s onwards a great many vessels became nipped in the ice, having been compelled to travel ever further north in search of the ever less populous whales, forcing crews to stay in the Arctic over winter. Increasingly, ships also came back half-empty or completely 'clean', having made few or no catches. British Arctic explorations suffered a series of mid-century tragedies, perhaps the most famous being the disappearance of Sir John Franklin and his crew in 1845, as they were trying to locate the so-far elusive North-West Passage; all 129 men died.[33] It was

Fig. 2.13 Thomas Binks, *The 'Jane', 'Viewforth', and 'Middleton' Fast in Ice* (1836), oil on canvas, 75 x 100 cm © Hull Maritime Museum (KINCM:2007.1327)

47

these human tragedies that preoccupied the artists of the Hull School, especially in their later works. For example, Binks's The 'Jane', 'Viewforth' and 'Middleton' Fast in Ice (1836) (see fig. 2.13) commemorates the terrible 1835 season when five Hull whale ships were lost; the Middleton of Aberdeen was also crushed in the ice and its crew had to be taken aboard by its fellow vessels.[34] The Jane of Hull stands in the middle, a May Day garland hanging forlornly from its main, top gallant stay, whilst the Middleton and its sister Scottish vessel, the Viewforth, are visible on either side. The ice extends across the composition, with no respite from the environment, as figures in the foreground rally around trying to remedy their situation.

The most defining episode of Hull whaling was, however, that of the Diana, which acted as an epitaph for the industry in the city. In 1866, the Diana, while on a routine whaling expedition, became frozen in the ice and was trapped for six months. The ship's captain, John Gravill, and many of the crew died in the incident.[35] The surgeon on board, Charles Edward Smith, kept a journal, and a number of his illustrations from the voyage acted as the base for further paintings, including R.D. Widdas's Diana Gripped in the Ice (1867) (see fig. 2.14). A heavy and continuous Arctic winter darkness envelops the scene, with the moon offering the only form of illumination. Surrounded by an array of ice formations, the central vessel sits precariously on its side, evoking the desperate situation of the crew emphasised by the lack of indigenous animal life, exaggerating the lonely emptiness of the space. As in Binks's work, however, the figures in the foreground remain

Fig. 2.14 Richard Dodd Widdas, 'Diana' Gripped in the Ice (1867), oil on canvas, 48 x 65.5 cm. © Hull Maritime Museum (KINCM:2007.1337)

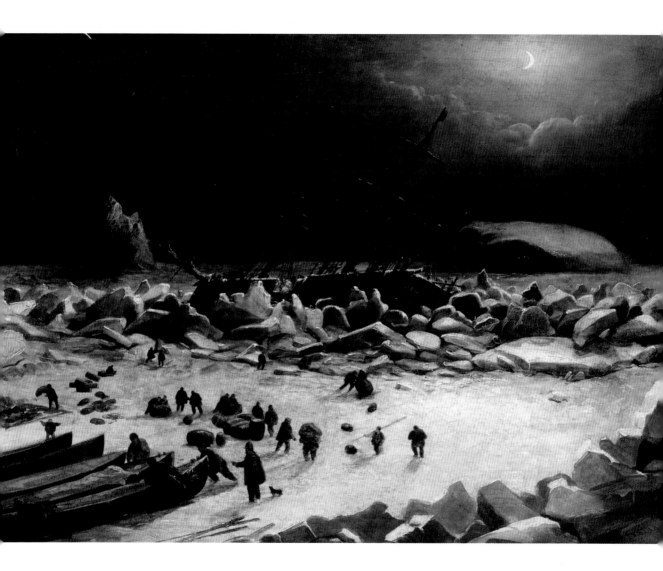

resilient, demonstrating a certain human ingenuity in such a hostile zone, carrying supplies and dragging whaleboats, accompanied by man's best friend, in the form of Smith's dog, Gyp, who despite surviving a number of months aboard was eventually shot, with 'a heavy heart', by his owner, on showing the first signs of hydrophobia. Gyp was, however, outlived by two other on-board pets – the captain's canary and a linnet belonging to the engineer. These were clearly animals in a different category from those that the whalers were keen on hunting.[36]

The Hull School of painters, then, represent a distinct group of local artists, who built on a long Anglo-Dutch tradition of whaling painting and prints, as well as drawing on contemporary narratives of Arctic exploration. As in the industry itself, the whales in the Hull School canvases are exploited as commercial goods in the wider depiction of man's prosperity in the region, who, when disaster strikes, are absented so that human tragedy can take centre stage.

ENDNOTES

1 The Dutch golden age saw the growth in painting, science, trade and the military, and expanded from the provinces to the core of the nation. For more, see Simon Schama, *The Embarrassment of Riches: An Interpretation of Dutch Culture in the Golden Age* (New York: Knopf, 1987).

2 For more information about the process of conservation, see 'Whale tale: a Dutch Seascape and its lost Leviathan', http://www.cam.ac.uk/research/news/whale-tale-a-dutch-seascape-and-its-lost-leviathan (Date of Access: 12 Dec 2016).

3 Erica Fudge, *Animal* (London: Reaktion, 2002), 8.

4 Julie Urbanik, *Placing Animals: An Introduction to the Geography of Human-Animal Relations* (Lanham: Rowman and Littlefield, 2012).

5 Gordon Jackson, *The British Whaling Trade* (London: Adam and Charles Black, 1978), esp. 70–116.

6 For information relating to whaling prints, see Elizabeth Ingalls, *Whaling Prints in the Francis B. Lothrop Collection* (Salem: Peabody Museum of Salem, 1987). For information on John Wilson Carmichael, see Andrew Greg, *John Wilson Carmichael 1799–1868* (Newcastle: Tyne and Wear Museums, 1999).

7 For a more synoptic catalogue of the Hull School artists and their works, see Arthur G. Credland, *Marine Painting in Hull: Through Three Centuries* (Beverley: Hutton Press, 1993).

8 These are just a number of the names that can be counted as figures of the Hull School. Others include Henry Redmore and Thomas Jacques Somerscales, alongside a host of anonymous artists. For a full list of names practising marine painting in Hull, see Credland, *Marine Painting in Hull*, esp. 199–215.

9 For the full list of works in the Hull Museum Collection and Ferens Art Gallery collection, see Hazel Buchan-Cameron, *The Public Catalogue Foundation, Oil Paintings in Public Ownership East Riding and Yorkshire* (Frome: Butler Tanner and Dennis, 2010). The New Bedford Whaling Museum holds four paintings by Ward. For more, see *Treasures of the Whaling Museum Touchstone to the Region's Past* (New Bedford: Old Dartmouth Historical Society/New Bedford Whaling Museum, 2015). A further painting by Ward is held at the National Gallery of Art, Washington, D.C. For more, see Franklin Kelly, 'John Ward of Hull, *The Northern Whale Fishery: the "Swan" and "Isabella"*, *Bulletin / National Gallery of Art* 38 (2008), 20.

10 There was a 1981 exhibition *John Ward of Hull, Marine Painter 1798–1849*, at the Ferens Art Gallery, to coincide with the opening of the Humber Bridge, and a 1951 exhibition of marine painting as part of the Festival of Britain Exhibition. For more, see Arthur G. Credland, *The Hull Whaling Trade: An Arctic Enterprise* (Beverly: Hutton Press. 1995); *Henry Redmore of Hull, Marine Artist 1820–1887* (Hull: Hull City Museums and Art Galleries, 1987); and *John Ward of Hull, Marine Painter 1798–1849* (Beverley: Hutton, 1981); as well as Gordon Bell, Heather Birchall and Arthur G. Credland, *Northern Seascapes and Landscapes* (Pickering: Blackthorn

Press, 1987); and Vincent Galloway, *Early Marine Paintings and Hull Art Directory* (Hull: Ferens Art Gallery, 1951).

11 Alison Hokanson, *Turner's Whaling Pictures* (New York: Metropolitan Museum, 2016), 15. For recent, sophisticated scholarship on marine painting, see Geoff Quilley, *From Empire to Nation: Art, History and the Visualization of Maritime Britain, 1768–1829* (New Haven: Yale University Press, 2010); Christine Riding and Richard Johns, *Turner and the Sea* (London: Thames and Hudson, 2013); Eleanor Hughes, ed., *Spreading Canvas: Eighteenth-Century British Marine Painting* (New Haven: Yale University Press, 2016); and Sarah Monks, *Marine Painting in Britain 1650–1850: Framing Space Power and Modernity* (London: Routledge, forthcoming 2018).

12 E.H.H. Archibald, *Dictionary of Sea Painters* (Woodbridge: Antique Collectors' Club, 1980).

13 For more, see Charles Edward Smith, *The Nightmare Voyage of the Diana* (Lerwick: Shetland Times, 2014).

14 Credland, *Marine Painting in Hull*, 31.

15 Archibald, *Dictionary of Sea Painters*, 229.

16 Bell, Birchall, and Credland, *Northern Seascapes and Landscapes*, 56.

17 Harriet Ritvo, *The Animal Estate: The English and Other Creatures in the Victorian Age* (Cambridge: Harvard University Press, 1987).

18 John Barrow, quoted in U.C. Knoepflmacher and G.B. Tennyson, eds, *Nature and the Victorian Imagination* (Berkeley: University of California Press, 1997), 95.

19 James Ayres, *Art, Artisans and Apprentices: Apprentice Painters & Sculptors in the Early Modern British Tradition* (Oxford: Oxbow, 2014), 235.

20 For more, see Richard Johns, 'After Van de Velde' in Hughes, *Spreading Canvas*, 16–38; and Roger Quarm, 'British Marine Painting and the Continent, 1600–1850', *Mariner's Mirror* 97.1 (February 2011), 180–192.

21 David Solkin, ed., *Turner and the Masters* (London: Tate, 2009), 50, 52.

22 Hughes, *Spreading Canvas,* 8–10.

23 For more on other regional schools of painting, see Josephine Walpole, *Art and Artists of the Norwich School* (Suffolk: Antique Collectors' Club, 1997); Denys Brook-Hart, *British 19th-Century Marine Painting* (Woodbridge: Antique Collectors' Club, 1974); and C. Geoffrey Holme, and A.L. Baldry, *British Marine Painting* (London: The Studio, 1919).

24 Ingalls, *Whaling Prints in the Francis B. Lothrop Collection*, 9; and Stuart M. Frank, *Classic Whaling Prints and Their Original Sources from the Permanent Collection of the New Bedford Whaling Museum* (New Bedford: Old Dartmouth Historical Society/New Bedford Whaling Museum, 2016), 17–29.

25 Pieter van der Merwe, 'Huggins, William John (1781–1845)', *Oxford Dictionary of National Biography,* http://www.oxforddnb.com/view/article/14053 (Date of Access: 26 December 2016).

26 Credland, *The Hull Whaling Trade,* 50.

27 *The Exhibition of the Royal Academy* (London: W. Clowes and Sons, 1840), 12. For more, see Credland, *John Ward of Hull*; and 'John Ward (1798–1849)', *Oxford Dictionary of National Biography,* http://www.oxforddnb.com/view/article/109554 (Date of Access: 26 December 2016). See also D. Harbron, 'John Ward, Painter (1798–1849)', *Burlington Magazine* 79 (October 1941), 130–134.

28 Ross had set out to locate the North-West Passage in 1829, but had to abandon the mission after his ship got stuck in ice, and spent the next four years in the Arctic. For more, see Sir John Ross, *Narratives of a Second Voyage in Search of a North-West Passage and of a Residence in the Arctic Regions During the Years 1829, 1830, 1831, 1832, 1833* (London: G.W.M Barnard, 1844), esp. 519– 525.

29 Barry Venning, 'Turner's Whaling Subjects', *Burlington Magazine* 12.983 (February 1985), 79.

30 William Scoresby Jnr, *An Account of the Arctic Regions with a Description of the Northern Whale-Fishery* (Edinburgh: Constable, 1820), II: 203.

31 Scoresby, *An Account of the Arctic Regions,* I: 467.

32 Credland, *Marine Painting in Hull,* 164.

33 For more, see Frédéric Regard, *Arctic Exploration in the Nineteenth Century: Discovering the Northwest Passage* (London: Pickering and Chatto, 2013).

34 Credland, *The Hull Whaling Trade,* 40.

35 For more information on the *Diana,* see Smith, *The Nightmare Voyage of the Diana.*

36 Smith, *The Nightmare Voyage of the Diana,* 106, 116.

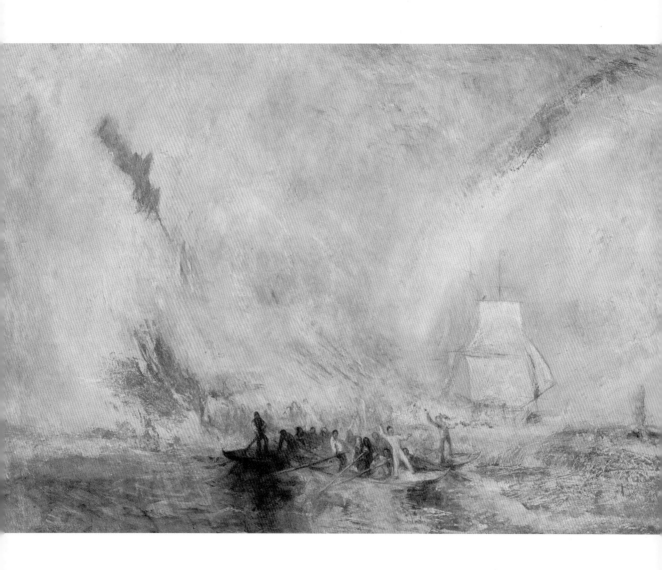

Chapter 3
Turner and the Whale/rs, c.1845–46

Jason Edwards

INTRODUCTION: TURNER, IN THE CIRCUM-POLAR WORLD

In the summer of 1845, whilst 14 Hull whalers were hunting in the Arctic, and following a parliamentary commission considering the future of the whaling trade in 1844, acclaimed Victorian painter J.M.W. Turner exhibited a pair of canvases devoted to whaling at the Royal Academy summer exhibition in London (see figs 3.1 and 3.2). Both entitled *Whalers,* the pictures referenced respectively pages 163 and 175 of Thomas Beale's influential *The Natural History of the Sperm Whale* (1835). Like many of Turner's titles, the subtitles of the *Whalers* sent viewers on a wild goose chase. If the

Fig. 3.1 J.M.W. Turner, *Whalers* (c.1845), oil on canvas, 91.1. x 121.9 cm. Accepted by the nation as part of the Turner Bequest, 1856. © Tate, London (N000545)

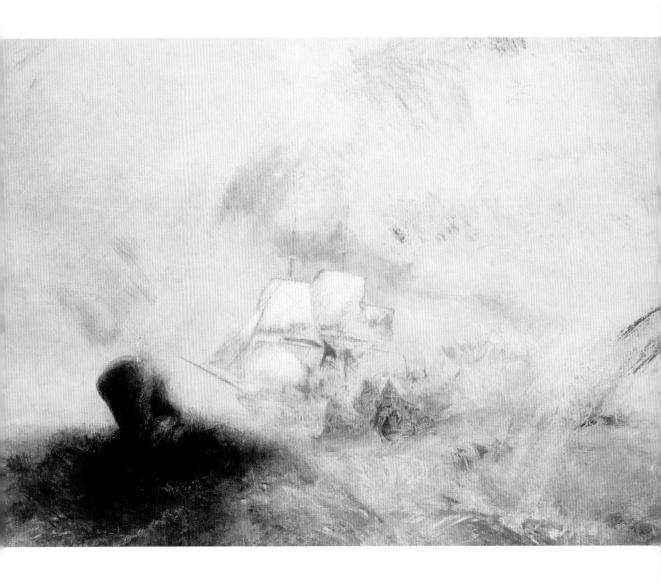

scene of the whalers 'with their harpoons held above their heads', in pursuit of a 'large "hump" projecting three feet out of the water', the topic of Turner's first image, occurred on page 163; the final capture of the whale, the subject of the second, took place across pages 173–176, where Beale described the whaleboats struck with such velocity that they were thrown 'high into the air', fracturing them 'to atoms', leaving the crew floundering in the water, waiting for other boats to 'relieve them from their dangerous situation'.[1] What we do not learn from Turner's canvas, but readers of Beale would have ascertained, is that before it can be hacked up and rendered down, the sperm whale Turner depicted in his second picture sank to the bottom of the Pacific; an ocean locale where so-called 'scientific' whale hunting continues until this day.

Turner's *Whalers* (see figs 3.1 and 3.2), now divided between Tate Britain, in London, and the Metropolitan Museum, in New York, were succeeded, in 1846, by a second pair of whaling canvases; just as a 40-foot Greenland whale, stranded in Caernarvon Bay, was towed into Liverpool on 4 May. The overall quartet of pictures, forming a sequential narrative, were designed to capitalise on the contemporary taste for whaling and polar exploration narratives, and the rise of the serial novel from the 1830s. Hung in separate rooms at the Royal Academy, *Hurrah! for the Whaler Erebus! Another Fish!* and *Whalers (Boiling Blubber) Entangled in Flaw Ice, Endeavouring to Extricate Themselves*, are both now housed at Tate. Like its predecessor, the first of Turner's 1846 *Whalers* referenced Beale, this time without a page number, although

Fig. 3.2 J.M.W. Turner, *Whalers* (c.1845), oil on canvas, 91.8. x 122.6 cm. © The Metropolitan Museum of Art, New York; Catharine Lorillard Wolfe Collection, Wolfe Fund, 1896 (96.29)

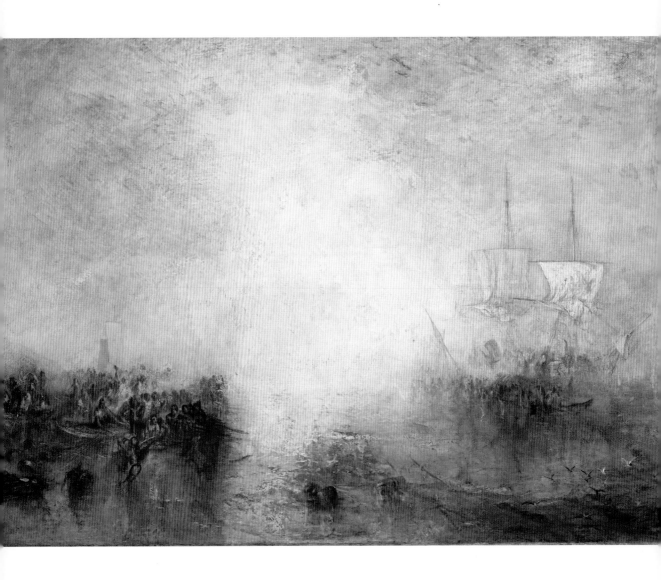

readers might have recalled, from the previous year, Chapter 14, 'Of the "Cutting In" and "Trying Out"', where, as in *Hurrah! for the Whaler Erebus! Another Fish!*, the sailors cheer when they capture the last carcass they require to sail home.[2]

Following Turner's death in 1851, the first, third and fourth of the *Whalers* entered the National Gallery, as part of the Turner Bequest; with *Hurrah! for the Whaler Erebus! Another Fish!* being posthumously engraved by Robert Brandard, for *The Turner Gallery* (1859–61).[3] The Met *Whalers*, by contrast, passed through a series of private hands across the nineteenth century, before arriving in the Met collection in 1896; an event whose 120th anniversary the curators celebrated, in the summer of 2016, by publicly exhibiting the whaling quartet, for the first time, as an ensemble.[4]

Although the Royal Academy quartet were not Turner's only depictions of whales and whalers, I focus, in this essay, on the 1845–46 quartet.[5] To date, the mid-1840s have been considered a pivotal moment in Turner's biography and polar studies. Arctic historians Chauncey Loomis and Robert G. David suggest that the first period of Victorian interest in the poles concluded in 1845, with the departure of the disastrous Franklin expedition that year, ending a period of confident exploration and passion for finding a north-west passage to India, and leading to a period dominated by increasingly desperate searches for the lost explorers.[6] David also suggests that 1845 was the pivot point at which Victorian depictions of the Arctic morphed from the technicolour fireworks of popular panorama displays of the region to the monochrome character of subsequent newspaper engravings

Fig. 3.3 J.M.W. Turner, *Hurrah! for the Whaler Erebus! Another Fish!* (c.1846), oil on canvas, 90.2. x 120.6 cm. Accepted by the nation as part of the Turner Bequest, 1856. © Tate, London (N000546)

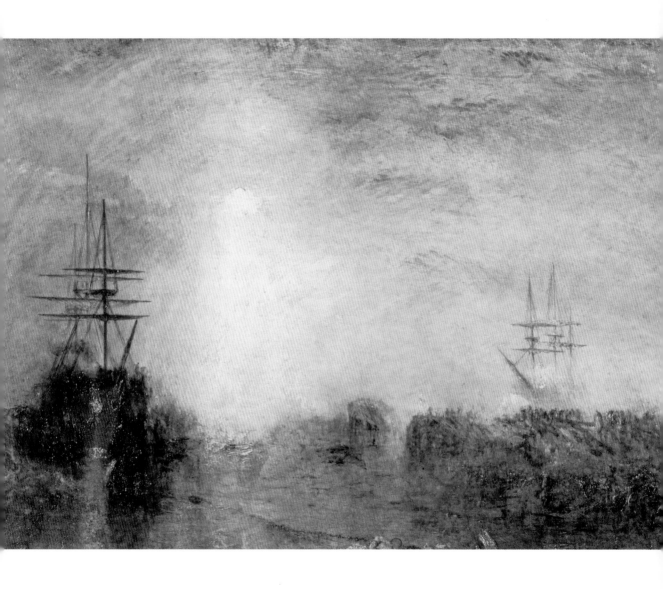

and photographs; an increasing bleaching that partly explains the mixed contemporary press reception Turner's canvases received, as we shall see.[7]

The year 1845, meanwhile, saw Turner on the Royal Academy's hanging committee and stepping up to be its acting President, whilst 1846 was the year in which he moved to Chelsea, and into relative anonymity, with his long-term companion, Sophia Booth; in which his health began to deteriorate; in which his exhibiting career began to decline; and in which his reputation was defined for the following 150 years. For example, according to John Ruskin, who had recently published his defence of Turner, the first volume of *Modern Painters* (1843), and acquired Turner's *Slave Ship* in early 1844, the painter suffered a 'fatal change' in late 1845.[8] Indeed, Ruskin considered *The Fighting Temeraire* (1839) Turner's last great work and found the *Whalers* 'altogether unworthy' of his idol.[9] In 1902, however, art critic Walter Hamilton took a different view, representative of Turner's twentieth-century reputation, when the critic noted how fashionable Turner's 1840s works were becoming, leading to the triumph of the painter's late, abstract style across the twentieth century.[10]

Subsequent scholars have considered Turner's *Whalers* in numerous critical and exhibition contexts, including his sketchbook practice, interest in the sublime, modern life subjects, late style and seascapes, depictions of the English channel, and relations to his industrial patrons. In addition, Robert K. Wallace has focused on the painter's

Fig. 3.4 J.M.W. Turner, *Whalers (Boiling Blubber) Entangled in Flaw Ice, Endeavouring to Extricate Themselves* (c.1846), oil on canvas, 89.9. x 120 cm. Accepted by the nation as part of the Turner Bequest, 1856. © Tate, London (N000547)

Antarctic sources and the potential inter-relation of Turner's canvases and Herman Melville's seminal whaling novel *Moby-Dick* (1851);[11] whilst numerous commentators have posited a connection between Turner's *Whalers* and his friendship with Elhanan Bicknell, the part owner of a spermaceti import and processing, as well as candle-manufacturing, business.[12] Indeed, shortly after Turner's death, John Burnett claimed that all four *Whalers* were painted for Bicknell.[13] Bicknell was one of Turner's most significant patrons, buying some eight oils in 1844 alone, the year before Turner exhibited his first *Whalers*. Turner clearly had Bicknell in mind the following winter, writing to him on 31 January 1845 to invite him to visit his Queen Anne Street studio 'for I have a whale or two on the canvas'.[14] Turner's gambit paid off in the short term. Bicknell briefly acquired the Met *Whalers,* the only one to find a buyer, but later returned it, having found evidence of watercolour on a canvas he bought as an oil.[15]

In the remainder of this essay, I further examine the *Whalers* in the context of their literary and scientific sources, Turner's biography, and what I, following famed nineteenth-century Whitby whaler William Scoresby junior, call the *circum-polar world*. In so doing I make the overall argument that, like Turner's controversial *Slave Ship*, his *Whalers* can be characterised by a new ethical complexity.[16] In making my case, I use the *Whalers* to develop Leo Costello's argument that Turner sought to elevate the genres of land- and seascape to 'address the moral and narrative imperatives of history painting'.[17] Further, even if he did not like the whaling pictures, readers might think of this essay also developing the tradition of Ruskin, whose writing on Turner combined, in the words of Sam Smiles, a 'profound understanding of natural forces' with an emphatically 'ethical standpoint deriving from that understanding'.[18]

THE BIRDS AND THE BEACH, OR, TURNER'S EMPATHY

To date, scholars have emphasised Turner's 'ecological empathy' for his fellow creatures, and it is likely that most contemporary viewers, especially outside of Japan, have an 'instinctive sympathy' for his whales, given the International Whaling Commission's ban on commercial whaling in 1986.[19] For example, with animal ethics in mind, David Hill examined the numerous illustrations of live and dead birds that Turner contributed to the Farnley *Ornithological Collection*, an album of watercolour studies, interleaved with birds' feathers (1815–20), that was made for Turner's friend and patron Walter Fawkes. Much loved by Ruskin, the surviving drawings are now predominantly in the collections of Leeds City Art Gallery, with other examples at the Whitworth in Manchester, the Ashmolean in Oxford, and the Indianapolis Museum.

According to Hill, Turner was interested in ornithology, and his immediate circle was characterised by 'something of the modern conservationist spirit', with Charles Waterton creating a 'bird sanctuary at Walton, threatening to strangle gamekeepers who molested the owls, and building nesting boxes on top of his gateway'. In addition, Hill documents that Turner's 'identification with birds' was a 'recurrent theme', with the painter's nicknames including 'Old Blackbirdy', on account of the 'protection he gave to the birds' in his Twickenham garden.[20]

However, how do we square Hill's claims that Turner identified and empathised with birds with the fact that the painter documented his 'achievement' in killing a Cuckoo on Farnley Moor? In addition, Hill notes that, of the 20 bird studies now at Leeds, most 'shown whole are dead', and that, of the 'six whole birds, the two that are drawn from life, the *Robin* and the *Goldfinch*, are conspicuously weaker in execution and observation', their quality resulting from Turner's 'working from fleetingly

observed specimens'. For real 'observation and recording', Hill suggested, 'dead specimens were necessary', although, 'for the most part Turner avoided having to confront their being dead by concentrating on the heads only', so as not to have to acknowledge, as he did with the dead kingfisher, wood pigeon, grouse and jay, that the birds were 'pathetic corpses'.[21] In these cases, however, Hill argued, Turner made his viewers confront the birds' 'lifelessness as well as their beauty'. Also, for Hill, Turner's images were not those of a 'scientific ornithologist' because they focused less on the structures of feathers and the underlying skeleton than on expressing the 'delight of close scrutiny' and a 'care and love' for the birds, which was their 'real subject'.[22]

According to Hill, Turner probably felt empathetic towards his avian subjects because the illustrations were made around the moment at which his patron's brother had been killed in a hunting accident. However, the album was fashioned amidst a sustained culture of shooting at Farnley, whose owner, Fawkes, the painter's friend, customarily sent Turner a Christmas gift of game to his London residence; a fact he recalled, in December 1844, whilst at work on his 1845 *Whalers*, when a gift of a Yorkshire pie, filled with game, reminded him of the happy times he had spent at Farnley in the mid-1810s.[23]

It is perhaps unsurprising if Turner's attitude to game and avian life was ambivalent since the painter's uncles included a butcher and fishmonger. Mandy Swann has recently considered Turner's relation to fish in more detail in a self-consciously eco-critical article, 'Replenishing the Void: Turner's *Sunset at Sea, with Gurnets*' (2014), where she examined Turner's depictions of fish in the context of Romantic 'portrayals of marine animals' as either 'sublimely monstrous' or 'raw materials for industry, study, sport, or supper', with both frameworks sanctioning 'human domination and exploitation of the sea'.[24]

For Swann, Turner's *c.*1836 watercolour depiction of gurnets combined a degree of 'anthropomorphism with an essentially naturalistic portrayal', so that Turner could resist his peers' more 'utilitarian portrayals' of marine life. However, even for Swann, the question remained regarding how *sustained* Turner's empathy with marine animals was across the more than 30 representations she believed Turner produced, especially since 'only six' displayed them 'alive and in water'. However, even these images are, I would argue, quantitatively insignificant when compared to Turner's lifelong 'ardour for fishing', and the more than 200 images he fashioned with the word 'fish' in the title.[25]

For example, when it came to fishing – perhaps the closest parallel activity we have to that depicted by Turner in the *Whalers* – his first biographer, Walter Thornbury, documented that the painter was an 'intensely persevering', if 'very tender-hearted' angler, whose 'hesitation', when it came to whether to keep a fish or throw it back, was 'often almost touching'.[26] We also know from the evidence of the 200 or more relevant images in the Turner Bequest that he was a painter concerned, across his life's work, with both line and net fishing; with river, coastal and deep sea, and leisure and commercial fishing, as well as with the practices of sorting, cleaning and selling fish, on the beach and at markets, in the United Kingdom, France and Italy.[27]

Indeed, across his career Turner provided studies of a wide range of fish and seafood including plaice, dogfish, tench, trout, whiting, tuna, flounders, salmon, perch, mackerel, cod and, gurnards, as well as eels, prawns and lobsters. In addition, Turner fashioned more than ten fishing-themed images in 1845–46 alone, making his whales just 'another fish', even if he would have been aware – from volumes five and six of British Museum zoologist J.E. Gray's *Zoology of the Erebus and Terror* – of eighteenth-century naturalist Linnaeus's argument that the whale, because of its warm

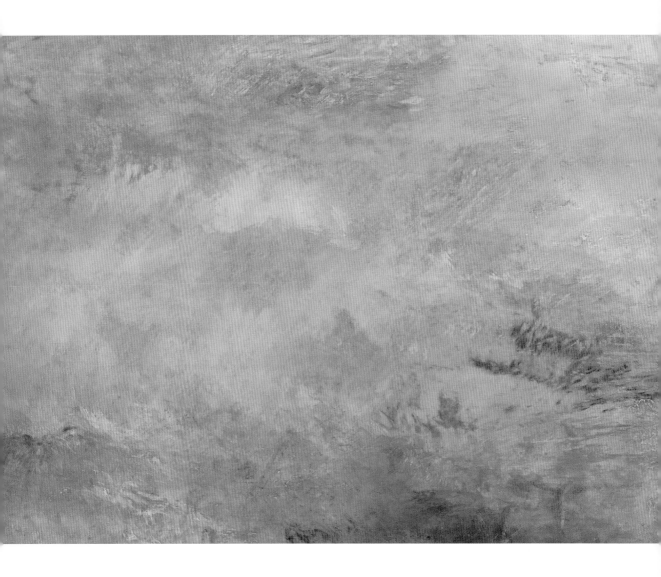

blood and lungs, was a mammal, not a fish. After all, Turner owned volume five of Gray's *Zoology – Fishes* (1845) – which contained no whales, but which advertised the forthcoming volume six, *On the Cetaceous Animals* (1846).[28]

However, if Turner was, according to Swann, 'certainly aware of the concept of extinction', from his whaling sources if nowhere else, as we shall see, even she had trouble resolving the character of the whaling pictures. On the one hand, Swann suggested that the 'pathos and gore' of the 'images of blood and water mixing' were likely to be familiar to a painter used to seeing the two fluids 'mixing in his father's barber shop' from an early age. On the other, she argued that such images might have anticipated Turner's never-to-be-realised 'work on the apocalypse which he intended to call "The Water Turned to Blood"'; and that the *Whalers* risked being too 'fantastical and obscure' in their representation of marine animals and the sea 'too monstrously alien to elicit sympathy'.[29]

Wallace, by contrast, the scholar who has explored the *Whalers* most thoroughly, argued confidently that the canvases reveal Turner's 'great sympathy for the whale as a living creature', and that the painter 'envisioned a world in which whales might some day be allowed to swim unmolested'.[30] For instance, Wallace pointed to the poignant way in which the whale's head 'hangs in anguish' in *Hurrah! for the Whaler Erebus! Another Fish!* – a detail missing from the posthumous Brandard engraving.[31] Wallace also made a case for the 'voiceless

Fig. 3.5 J.M.W. Turner, *Stormy Sea with Dolphins* (c.1845), oil on canvas, 91 x 102 cm. Accepted by the nation as part of the Turner Bequest, 1856. © Tate, London (4664)

anguish', 'mute sublimity', and 'evanescent essence of animal life' in Turner's post-1835 work; and suggested that Turner's *Sunrise with Sea-Monsters* and *Stormy Sea with Dolphins* (both *c.*1845) represented his need to 'repopulate the liquid spheres with living creatures of his own imagination' (see fig. 3.5). In addition, Wallace argued that what distinguished Turner's whales from those of his peers was the 'intensity of personal feeling' with which he imbued them. Indeed, for Wallace, the *Whalers* represented a 'pictorial condensation of the unspeakable and inarticulate emotion of a stout man whose most powerful works had been subjected to unpitying ridicule', the lances and harpoons corresponding to the 'journalistic barbs' his canvases had received. Wallace's Turner also shared his aged sperm whale's 'navigational, respiratory, and digestive afflictions'; and feared that his works might, like Beale's whale, 'sink out of sight' in spite of all his efforts.[32] Thus, for Wallace, the canvases 'invite each of us to open' our minds and hearts to those 'liquid [and] mammalian spheres that continue to expand and contract before our very eyes'.[33]

I am highly sympathetic to Wallace's ecological stance, but I think Turner's attitude in the *Whalers* is harder to pin down. After all, Turner's lifetime might have witnessed a marked advance in legislation seeking to protect animals, with the passing of the Cruel Treatment of Cattle Act in 1822; the founding of the Society for the Protection of Animals in 1825, which became the Royal Society for the Protection of Animals in 1840; and two broader anti-cruelty to animals acts in 1835 and 1849; but if Turner is anything like his peers and sources, he might have been intermittently sympathetic to the suffering of whales, but that does not mean that his pictures make an unequivocal case for the end of the whaling industry.

TURNER AND THE WHALERS, 1: *A JOURNAL OF A VOYAGE TO GREENLAND*

Turner was a friend of George William Manby, the author of a famous whaling narrative, the *Journal of a Voyage to Greenland in the Year 1821* (1822), which recounted how he travelled to the Arctic aboard one of Scoresby's whale ships to test the reliability of his new harpoon gun. This was a device closely related to Manby's earlier life-saving gun that fired a rope at sinking ships so that shipwrecked sailors and passengers could drag themselves ashore. The earlier gun was first demonstrated in 1812, and Turner had depicted it, and Manby's more famous invention, distress flares, in his 1831 canvas, *Boat and Manby Apparatus Going Off to a Stranded Vessel Making Signal (Blue Lights) of Distress* (see fig. 3.6).[34]

Turner had evidently read Manby's *Journal* with interest and in detail. Like the title of *Hurrah! for the Whaler Erebus! Another Fish!*, Manby repeatedly referred to whales as 'fish', and used exclamation marks for expressive emphasis. We hear cries, in the *Journal*, of 'a fish! a fish!', as well as shouts of 'A fish!! Lower away the boats!'[35] However, as these first quotations and Manby's patented harpoon-gun both indicate, his sympathies were not straightforwardly with the whales. Indeed, Manby clearly rooted for the whalers more than their quarry. He argued that the 'Greenland whale fishery afforded the best nursery for a hardy race of sailors'. He also informed his readers that the 'life of a sailor' was 'at all times precarious, and deserving the serious regard of every man who is a well wisher to his country; for sailors, by their honorable and useful exertions, have been the essential means of raising Britain above the rest of the world, in commerce and in naval power'. As a result, 'those who speak of philanthropy' must 'feel for the situation of these men, and will not withhold from them their keenest

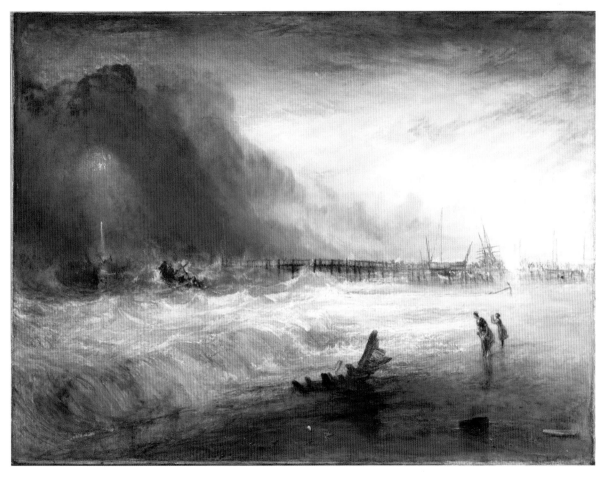

Fig. 3.6 J.M.W. Turner, *Boat and Manby Apparatus Going Off to a Stranded Vessel Making Signal (Blue Lights) of Distress* (1831), oil on canvas, 91.4 x 122 cm. © Victoria and Albert Museum, London (D36212)

sympathy';[36] views encapsulated in *Whalers (Boiling Blubber)*, which depicts the actions of a group of hardy whalers (on the right) hacking through the ice in which their ship is trapped.

In his *Journal,* Manby argued that his new harpoon-gun was 'desirable on the ground of humanity', since it more 'quickly terminat[ed] the misery of the fish, and obviat[ed] the necessity of the barbarity often unavoidable in the present system'. This 'called forth on the whale fishery' the 'clamorous indignation of some who possessed the finer feelings of sensibility'. In addition, Manby argued, the use of explosive shells would 'remove the most dangerous part' of the hunt by 'lacerating the vitals' of the whale, 'in perfect security, at a distance beyond the reach of the most enraged fish', thus presumably making dangerous scenes, such as that depicted in the Met *Whalers*, a thing of the past.[37]

Even if Manby was apparently sympathetic to the suffering of whales, he recognised that the Arctic whale fishery was a 'subject of paramount national importance', and he characterised whales as a 'valuable speculation'; when push came to shove, economic motives thrashed humanitarian ones. For example, when the whalers failed to catch their prey, Manby lamented that they lacked the 'reward which their efforts merited'. Indeed, Manby's call to fire 'missiles' at whales, an apparently 'judicious mode of attack', suggested they were a legitimate 'enemy' target, whose tails were a 'formidable weapon'.[38]

Like the title of Turner's *Hurrah! for the Whaler Erebus! Another Fish!*, Manby remained strategically uncertain regarding whether whales were mammal, fish, animal, vegetable, or mineral. For example, like Turner, Manby described whaling as a kind of 'fishing'. In addition, according to Manby, whales made 'a noise, not unlike that of a powerful blast furnace', suggesting they were more machine than man; the sound

of their blowholes anticipating the flaming try-works in which they would ultimately be rendered down, as in the fourth of Turner's *Whalers*. At other moments, however, as in the case of Turner's Met *Whaler*, Manby characterised the whale as a threatening, enraged 'monster of the deep' that deserved no sympathy. However, if whales were found in 'herds', and were to be 'classed with the quadrupeds', which they resembled in 'suckling [their] young', 'breathing air' and 'having warm blood and flesh composed of animal substance', as well as in being 'furnished with lungs' and 'other parts of a similar structure to those of land animals', their slaughter was akin to mainstream agricultural livestock production.[39]

Manby was certainly alive to questions of extinction and pollution, and probably unlike Turner, to the question of indigenous peoples' rights. For example, Manby was conscious that Arctic whales were 'on the decline, the quantity of fish being greatly reduced' by 'constant capture'; and he documented that 'the fishers, from a defect of whales' had begun to 'apply themselves to the seal fishery'. Even this, though, he feared, would not be of 'very long continuance; for these shy and timid creatures will soon be induced to quit those shores, by being so perpetually harassed; as, indeed, the walrus has in a great measure already done'. Indeed, Manby noted, the 'poor natives of Greenland' had already begun to 'suffer from the diminished number of seals in their seas, these fish being their principal subsistence; so that, should they totally desert the coast the whole nation would be in danger of perishing'.[40]

On the other hand, Manby was alert to two key developments in the marketplace: the 'vast reduction in the price of oil', thanks to the rise of the American whale fishery; and the increasing 'substitution of coal gas' to light the ports and cities of England – in other words the Victorians' ecologically catastrophic move to use fossil fuels.

To Manby, the 'advantage of gas produced from oil, compared with that obtained from coal' was 'so great' that he found it 'astonishing that oil gas is not in general use', since, unlike coal gas, it had 'no bad nor disagreeable quality', gave a 'far more brilliant light', and was 'cheaper' and more efficient, with 'one cubic foot of gas from oil, going as far as twice that quantity of coal gas', which was 'extremely offensive to the smell, dangerous to the health on being inhaled; and injurious to furniture, books, plate, pictures' as well, as we now know, to the natural environment.[41]

However, if, for Manby, the whale hunt 'presented a picture beyond the power of description', Turner seems to have risen to the challenge. For example, Manby's description of the 'indication' of the hunted whale's 'exhaustion, by a mixture of blood with the breath' and its 'tingeing the air with red' anticipates the scene on the right of the Tate *Whalers*. Turner's second whaling canvas illustrates Manby's account of how the 'agony the poor animal now appeared to be suffering, would, on any other occasion, have excited sentiments of unmixed compassion' were it not that the 'spectacle was rendered awfully grand by the astonishing exertions made by the fish with its fins and tail, to destroy its assailants'. On the right side of *Hurrah! for the Whaler Erebus! Another Fish!* Turner brought to life Manby's description of the way in which 'the whale-bone, jaw-bones, and whatever was valuable in the head, having been hoisted on board, the body, with all its appurtenances, was cut away from the tackles, and descended to the bottom of the deep'. The canvas's left side and exclamatory title also recalls Manby's account of the 'welcome shout which follows the death of a fish', especially as accompanied by flocks of fulmar petrels 'feeding on dead whales, or any other fleshy substance, that floats on the surface', like the birds in the lower right of the canvas. Finally, like *Whalers (Boiling Blubber)*, Manby documented the 'grease and filth that attended the unpleasant operation

of making off', or the 'business of paring and barreling' up the blubber, transforming the formerly 'chaste snow' to a 'dirty forbidding surface'.[42]

If Turner's canvases, then, evidently empathised as much with the whalers as the whales, he also identified with a range of other polar sailors, as we shall now see.

TURNER AND THE WHALERS 2: BRITISH EXPLORERS IN THE CIRCUM-POLAR WORLD

Unlike Wallace, Turner scholar Andrew Wilton felt sure that the painter's ultimate sympathies, like those of his sources, as we have seen, lay with the whalers rather than their quarry. For Wilton, the painter's four titles alone, each of which contain the world 'whaler' or 'whalers', betrayed Turner's interest, which focused on the 'activities of the whalers themselves, on the hardships they undergo, as well as on the pleasures of the chase'.[43] Also, if Venning believed that a modern audience could 'hardly appreciate what it meant to be imprisoned in the polar ice', as Turner's fourth set of whalers are, the painter had plenty of experience to draw on from his Alpine travels, even if he hadn't travelled to the Arctic, or suffered frostbite, starvation, or scurvy.[44]

After all, he had repeatedly visited the Swiss Alps on sketching tours (in 1802–03, and between 1836 and 1844), travelling there for the last time in the year in which he conceptualised the whaling quartet. By the mid-1840s, Turner was well known for his Alpine work, with some 19 Alpine subjects on display in 1819 alone, when the Fawkes collection opened to the public, and with Turner having already sold an Alpine watercolour to Bicknell in 1842.[45] Contemporaries often evoked polar images when they thought of Turner, with Benjamin Robert Haydon describing Turner as the 'Pole Star of Art';[46] whilst William Leitch Litchfield, in a famous account of Turner's Queen

Fig. 3.7 J.M.W. Turner, *Alpine Gorge* (*c.*1836), graphite and watercolour on paper, 24.5 x 34.7 cm. Accepted by the nation as part of the Turner Bequest, 1856. © Tate, London (CCCLXIV)

Anne Street studio, to which we shall return, noted that the painted surface on certain canvases was cracking 'in long lines, like ice when it begins to break up'.[47] In addition, as Loomis, Hill and Potter have documented, 'Alpine and Arctic scenery' were often invoked together in accounts of the Victorian sublime, with the Alps frequently compared to the 'seas of Greenland', and the polar world increasingly overtaking the Alps as the 'symbolic centre of sublimity in European thought'.[48]

Traditionally, scholars have imagined Turner's whaling pictures to be depictions of the 'open sea'; a 'deep ocean', in Turner's day, 'akin to deep space today: a vast and mostly unchartered realm that was often the stuff of fantasy', according to Hokanson.[49] However, if the deep sea was unknown to Turner, Alpine scenery certainly was not, and we might interpret, as icebergs, the luminous vertical columns of light at the heart of *Hurrah! for the Whaler Erebus! Another Fish!* and *Whalers (Boiling Blubber)*, and the grey patches against the white of both 1845 *Whalers* as indicating glacial ravines or valleys in the misty distance, like the one depicted in the Tate watercolour, *Alpine Gorge* (1836) (see fig. 3.7), especially since it is otherwise impossible to make sense of such grey smudges in atmospheric terms. If so, then the canvases are closely related to two diminutive Antarctic vignettes Turner worked on around 1844, *Ship and Iceberg* and *Ship Among Icebergs*; both are now in a private collection, but that came up at Christie's as part of the Taylor sale in 1912.[50]

Turner's experiences in the Alps, and in snowy weather more generally, must have made him unusually sympathetic to the plight of polar whalers. After all, he had supposedly had himself strapped, three years before the debut of the *Whalers*, to the mast of the *Ariel* in order to paint his 1842 canvas *Snow Storm: Steam Boat Off a Harbour's Mouth*. The filthy snow of *Whalers (Boiling Blubber)* recalls the painter's

experience of wading up to his 'knees in snow and muck' in order to attend the London funeral of Sir Thomas Lawrence in January 1830.[51] Also, Turner spent considerable time exploring the frozen terrain of the Brenla glacier, Glacier du Bois, Mer de Glace, and Glacier des Boissons, often painting 'from the surface of the ice', experiences captured in the *St Gothard and Mont Blanc Sketchbooks*.[52] In addition, five years later, Turner revealed his preoccupation, in the *Greenwich Sketchbook*, with 'darling' early-modern explorer Hugh Willoughby, writing a poem celebrating Willoughby's willingness to brave the 'rugged nature' of Greenland's 'icy bay', in search of a north-east passage to China, and lamenting his death 'in frozen regions'.[53]

Most relevant, however, were Turner's experiences in the Swiss Alps in the 1820s. In January 1820, for example, the painter's coach overturned at the summit of Mount Cenis, as he returned home from Italy, a scene depicted in the 1820 image *Snowstorm (Mount Cenis)*. Turner would later describe this experience in a January 1826 letter, which recalled how his carriage doors were 'so completely frozen' that he was 'obliged to go out a window', and walk up to his 'knees no less in snow all the way down'.[54] The painter was similarly forced to abandon his carriage in January 1829, this time finding himself even more like the whalers trapped in flaw ice, 'half starved and frozen', 'bivouacked in the snow with fires lighted for three hours', and forced to 'dig a channel' through the snow 'for the coach', before completing the journey 'on a sledge'. This was a scene he again recalled for posterity in *Messieurs Les Voyageurs on Their Return from Italy (par la diligence) in a Snow Drift Upon Mount Tarrar – 22nd of January 1829* (see fig. 3.8).[55]

Turner's identification with Arctic whalers is also apparent in the canvases themselves, in the way in which sailors repeatedly make eye contact with viewers, as

well as through the parallels Turner establishes between spectators trying, with difficulty, to resolve his emphatic facture down to detail, across the four *Whalers*, and the experience of sailors searching the horizon and surface of the sea for their prey. Turner makes that interpretation likely because of the way in which, when seen juxtaposed, the whales in the first two canvases are trapped between a pair of whaleboats and ships, moving inexorably in on their prey from opposite sides, in opposite directions. In addition, Turner includes a patch of rearing grey-and-white paint, resembling a bowhead whale, to the left-hand side of the boats in the Tate *Whalers* in the same position as, and in many ways resembling, the rearing sperm whale head in the Met painting, suggesting that experienced viewers, like veteran whalers, could anticipate where a whale would reappear at the surface of the water.

In Turner's period there was also a close relationship between polar whaling and exploration, a relationship signalled by the title of *Hurrah! for the Whaler Erebus! Another Fish!* From as early as 1862, when it was first noted by Thornbury, viewers have known that there was no British whale ship called the *Erebus,* as the name occurs nowhere in Lloyd's Register of Ships.[56] There was, however, a famous and topical H.M.S. *Erebus* setting sail around the time Turner was working on his canvases. This was the ship in which Franklin set out in search of the North-West Passage in 1845, amidst much pomp and circumstance; the single most important Arctic voyage of the century. Franklin and

Fig. 3.8 J.M.W. Turner, *Messieurs Les Voyageurs on Their Return from Italy (par la diligence) in a Snow Drift Upon Mount Tarrar – 22nd of January 1829* (1829), watercolour and bodycolour on paper, 54.5 x 74.7 cm. © British Museum, London (TW0393 /Wilton 405)

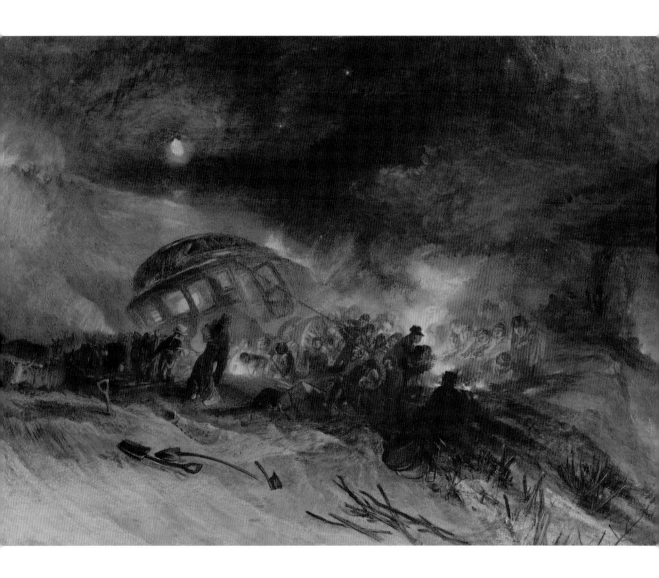

his crew famously went missing shortly after arriving in the Arctic. They were last spotted by two whale ships in July 1845, shortly after Turner's first *Whalers* went on display at the Royal Academy. Marshalled with sufficient supplies to survive three Arctic winters, an official search party was finally sent out in 1848, but not in time to save Franklin, who died, along with 23 of his men, in June 1847. None of this was known until August 1850, however, when the crew's winter quarters were discovered on Beechey Island. Four years later, in 1854, John Rae broke the terrible, controversial news that Franklin and his men had succumbed to the so-called 'last resort' of cannibalism, as reported by local Inuit sources, and made clear by the surviving state of some of the corpses as well as what had been found in the crew's kettles.

However, if all of this was to make retrospectively ironic the celebratory title of *Hurrah! for the Whaleship Erebus Another Fish!*, and poignant the scene of the whalers *Endeavouring to Extricate Themselves from the Flaw Ice* in Turner's fourth canvas, at the time in which he was at work on his third canvas the confident shouts of the men must have seemed merely topical. Topical not just because of Franklin's recent departure, but because the earlier career of the *Erebus* was much in the news in the 1840s, having returned, in 1843, from a successful, four-year voyage to the Antarctic, under Captain James Clark Ross, whom Turner may have known as the men were both members of the Athenaeum club.

The *Erebus* was newsworthy because Ross, in 1841, had mapped, for the first time, much of the Antarctic coast; and because, in 1845, Gray published the fifth, *Fishes*, volume of the *Zoology of the Voyage* – a book found in Turner's library, as we have seen – followed, a year later, by the sixth volume, *On the Cetaceous Animals*, classifying numerous whales, porpoises and dolphins; the latter perhaps explaining why Turner

was preoccupied with dolphins in his *Stormy Sea* around the same time. Joseph Dalton Hooker's *Summary of the Voyage* also seems a likely source for Turner's second pair of *Whalers*. Firstly because, as Wallace has noted, Turner's description of the whalers being *Entangled in Flaw Ice, Endeavouring to Extricate Themselves* finds a clear echo in Hooker's description of the way in which the *Erebus* was trapped in ice from December 1841 to February 1842, during which time the crews were, in Hooker's phrases, 'entangled' and 'extricated' themselves.[57] However, in addition to the possible connection to Ross, the title might also suggest that Turner identified with an earlier polar explorer, James Cook, since his whalers *Endeavouring to Extricate Themselves* recalls the H.M.S. *Endeavour*, the ship on which Cook explored the region on his second voyage; the overall nationalism of the Antarctic project is perhaps present in the subtle, Union-Jack-like red, white and blue tonality of the first two *Whalers*.

During his 1841 voyage, Ross and his crew, meanwhile, also discovered the volcanic Mount Erebus, whose smoke and ash might help explain the filthy ice in Turner's fourth *Whaler*, since Hooker had reported seeing immense 'clouds of black smoke' being 'vomit[ted] forth' from the summit;[58] and since Turner had long been interested in volcanic activity, depicting the *Eruption of the Souffrier Mountains* in 1815, Vesuvius erupting in 1817, and being resident in London in 1816, where air quality was profoundly affected by the eruption of Mount Tamora in Indonesia.

The skeletal forms of whales also seem to haunt the landscapes and cloudscapes of a number of Turner's *c.*1845–46 sketchbooks. It is worth returning to these images, in this context, because they suggest that Turner shared with his friend, the osteologist and palaeontologist, Richard Owen, an interest in whale skeletons from a scientific and evolutionary perspective; with Owen writing to J.W. Lubbock, Treasurer of the

Royal Society in 1839, recommending that the 'whaling industry be involved in collecting specimens for scientific study'.[59] Turner frequently visited Owen at the College of Surgeons in August 1845, and invited him to see his pictures at the Queen Anne Studio at the moment in which the first two *Whalers* were hanging there.[60]

Given their interests, the pair might have paid particular attention to the bottom-right-hand corner of the Tate *Whaler*, with its thick impasto, bone-white, horizontal, spinal forms visible just below the bleeding whale, where Owen might have anticipated finding Turner's signature. These recall the bleached-out skeletons of whales that were to be found in the Museum of the Hull Literary and Philosophical Society, as Turner would have known from Beale, who drew attention to the 'several fine skeletons' found there, where they were joined by that of a blue whale washed up in the mouth of the Humber in 1835.[61]

Turner's suggestions of whale skeletons in the Tate *Whalers* and *Whaling Sketchbooks* are imprecise, but it was difficult to come by illustrations of whale skeletons in the mid-1840s, as only whale and fish skulls were reproduced in the *Zoology of the Voyage of H.M.S. Erebus* volumes, not complete skeletons. However, the presence of even imprecise skeletons littering Turner's whaling works suggests that he was thinking of their potential extinction, since during the period Owen was most famous for his work re-articulating dinosaur skeletons. We know that Turner shared this interest in fossil palaeontology and geology from both his verse, and the fact that his library contained two volumes of the 1811 *Transactions* of the Geological Society.

If Turner was concerned with the potential extinction of the species, viewers might be inclined to read, in Ruskinian terms, Turner's final *Whaler* as an articulation of the ravages of industrial whaling on the formerly pristine polar landscape; a reading,

perhaps, difficult to resist in our perilous moment of climate change, carbon footprints and filthy fossil fuels. Indeed, the surface of the ice is so blackened in *Whalers (Boiling Blubber)* that it is difficult to tell if the sailors are cutting into, and trying to extricate themselves, from the ice as Turner's title suggests, or whether the canvas depicts the cutting into a whale carcass, on the right, and rendering the blubber, on the left.

Again, though Turner's oeuvre makes it difficult to know how to read this filth, we might follow Ruskin in arguing that Turner was alive to the 'tragedy of the industrial revolution and its ravages in the landscape';[62] and to the 'spectacle of atmospheric pollution',[63] especially if we think about the *Whalers* in relation to Turner's depictions of the burning Houses of Parliament *c.*1833–34. However, as Eleanor Hughes has documented, ships on fire were traditional in British marine painting in the Romantic period.[64] Furthermore, as Ian Hamilton has noted, if Turner often conveyed the 'dirtiness of … industry', he was frequently thrilled at the spectacle of the industrial sublime, in scenarios such as the forge scene in the *Wilson Sketchbook* (1796–97), *A Lime Kiln at Coalbrookdale* (1797), and *Keelman Heaving in Coals by Moonlight* (1836), all closely related to the depiction of burning blubber in Turner's final *Whaler*.[65] In addition, as Hamilton has again observed, there are 'no wrecked steamships' in Turner's corpus, amidst a sea of marine disasters, suggesting that he identified industrial maritime technology with progress, however precarious the apparent position of the whalers in Turner's fourth canvas might be.[66]

If Turner, then, identified as much with polar explorers and scientists as whales, in the last section I look at the materials he employed to create his *Whalers*, and at the studio in which they were fashioned, to ascertain, finally, his broader attitude to animals.

A MATTER OF LIFE AND DEATH, OR FASHIONING THE *WHALERS* AT QUEEN ANNE STREET

As paper conserver and historian Peter Bower has revealed, Turner employed animal products everywhere in his process; and, following Bower, we might note the importance to Turner of the practice of 'tub sizing' his often red-calf-leather-bound sketchbook, in which the surface of each sheet of paper was 'coated with forms of gelatin derived from animals', and, in particular, from 'trimmings or scrapings from leather, particularly vellum and parchment parings', as well as parts of rabbits, fish, calves, bullocks, buffalo and oxen. This is a fact, the 'importance' of which for Turner's work 'cannot be stressed enough', according to Bower, since Turner was 'very deliberate' when it came to his choice of papers, and since 'without the great increase in surface strength that all gelatin sizing gives to the paper', he 'would not have been able to work his surfaces to quite the degree that he did' in, for example, the *Whaling Sketchbooks*.[67]

We also know that Turner employed egg tempera on his canvases; used hog's hair, sable, squirrel, badger, horse and camel's hair brushes; drew sculptor John Flaxman with a crow-quill pen; and frequently used chalk in his sketchbooks, made, as T.H. Huxley would point out in a famous 1868 lecture, from the compressed bodies of millions of marine creatures.[68] In addition, as painting conservers Rebecca Hellen and Joyce H. Townsend have recently discovered, Turner made use of spermaceti oil, no doubt obtained from Bicknell's business, as well as unbleached beeswax, in some of his 1840s canvases, such as *The Opening of the Walhalla, 1842* (1843) (see fig. 3.9).[69]

To date, such documentation has represented the end of the story when it came to Turner's use of spermaceti, since Hellen and Townsend were primarily concerned with documenting 'the high risk of using heat in treating Turner's paintings, since spermaceti

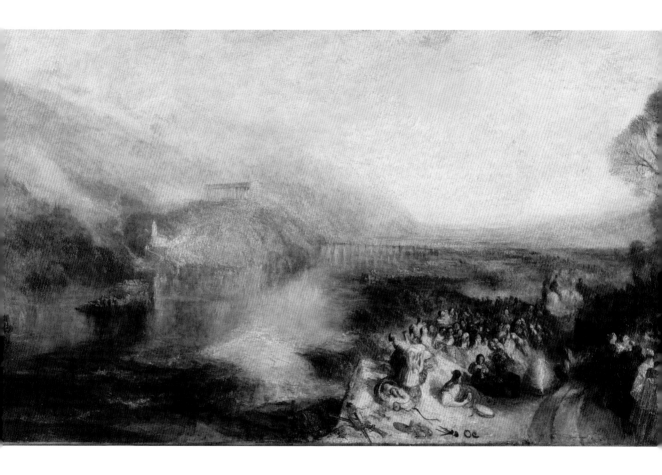

Fig. 3.9 J.M.W. Turner, *The Opening of the Walhalla, 1842* (1843), oil on mahogany,
112.7 x 200.7 cm. Accepted by the nation as part of the Turner Bequest, 1856.
© Tate, London (N00533)

wax has a very low melting point', rather than thinking about animal ethics. However, this is, perhaps, surprising given that three of Turner's *Whalers*, and numerous pages from the *Whaling Sketchbooks*, were included in the same exhibition, *Late Turner: Painting Set Free*, whose catalogue entries similarly make no reference back to the earlier conservation report, even though David Blayney Brown emphasises the 'relationship of materials to meaning'.[70]

However, the context of Turner's quartet of *Whalers* and of the studio in which they were made, makes the painter's use of spermaceti in the early to mid-1840s more difficult to ignore. I make this claim because of the account left by Leitch, which we have already briefly alluded to, who visited Turner's studio, where all four of the whaling canvases were on display, in the mid-1840s. I draw particular attention to Leitch's narrative because, as Sam Smiles has suggested, 'a decision about interior decorating can have historiographical implications'.[71] Leitch's account of Turner's by-then dilapidated studio is crucial for my argument because of the importance of the cats that inhabited it.

Lost momentarily in a reverie, in the studio, Leitch recalled being brought back to himself, suddenly, by 'feeling something warm and soft moving across the back of [his] neck; then it came on [his] shoulder, and on turning [his] head [he] was startled to find a most peculiarly ugly broad-faced cat of a dirty whitish colour', resembling the overall tonality of the Tate *Whaler*, 'with the fur sticking out unlike that of any other cat'. Its eyes were of a 'pinky hue', again recalling that of the Tate *Whaler,* and they 'glared and glimmered at me in a most unearthly manner'. The so-called 'brute' then moved across Leitch's chest, 'rubbing its head and shoulders against [his] chair'. The startled and unsympathetic Leitch 'put up [his] hand to shove the creature away, and,

in doing so, let [his] umbrella fall'. This 'startled four or five more cats of the same kind', which he observed moving about his legs in a 'most alarming way'. Leitch 'did not like the thing at all' and was 'frightened'. So he picked up his umbrella and made for the door, getting to the foot of the stairs as fast as he could. However, on looking back, he could see a number of 'cats at the top glaring' at him, every one of them 'without a tail'.[72]

That Turner owned cats is perhaps a surprising thing to draw attention to in an art-historical essay, but the way in which they were prioritised, at Queen Anne Street, over the canvases, should give us pause for thought, since it provides potential evidence for the depth of Turner's late devotion to the natural world over his own artistic practice. After all, as Leitch documented, Turner's *Fishing upon the Blythe-Sand, Tide Setting In* (1809) was not being well 'looked after', since it 'served as the blind to a window that was the private *entrée* of the painter's favourite cat, who one day, indignant at finding such an obstinate obstacle in her way, left the autograph of her "Ten Commandments" on the picture'. Turner, however, not averse to employing animal products on his canvases, was unconcerned, saying to his housekeeper, Hannah Danby, 'Oh, never mind'.[73]

CONCLUSION: TURNER AND THE WHALERS

Turner's complex quartet of *Whalers,* then, raise as many questions as they answer. Turner seems to identify as much, if not more, with his whaler, polar explorer and natural historian peers, as he does with his whales, whatever his critics say, and however much we would prefer this not to be the case. The painter's peers were faced with a difficult decision, as his canvases make clear: to accept the suffering and death of their

mammal cousins, whose oil would keep their economy lubricated, illuminated and afloat, or to choose an even more filthy world, marked by an even larger carbon footprint. We face a similar choice ourselves. As we look towards the middle of the twenty-first century and beyond, which forms of energy do we prioritise, and, with global meat consumption reckoned to double by 2050, which birds and mammals are we happy to cherish, and which to let perish to satisfy our violent, needlessly carnivorous pleasures?

ENDNOTES

1 Thomas Beale, *The Natural History of The Sperm Whale* (1835; London: Jan Van Voorst, 1839), 163, 173–176.

2 Beale, *Natural History,* 185–187.

3 For more, see Luke Herrmann, *Turner Prints: The Engraved Work of J.M.W. Turner* (London: Phaidon, 1990).

4 For more, see Alison Hokanson*, Turner's Whaling Pictures* (New York: Metropolitan Museum of Art, 2016).

5 The Metropolitan exhibition also included Turner's *The Great Whale,* or *The Whale on Shore* (1837). Designed as an illustration to Walter Scott's 1822 novel *The Pirate,* for the second volume of his *Landscape-Historical Illustrations of Scotland and the Waverley Novels* (1837), the image was not ultimately used; it was replaced by a design by Harden Signey Melville. For more on Turner's relation to Scott, see Gerald Finley, *Landscapes of Memory: Turner as Illustrator of Scott* (London: Scolar, 1980), and Katrina Thomson, *Turner and Sir Walter Scott: The Provincial Antiquities and Picturesque Scenery of Scotland* (Edinburgh: National Gallery of Scotland, 1999). In addition, as the *Brighton and Arundel Sketchbook* reveals, Turner sketched a whaleboat alongside the *Columbus,* in October 1824; and a tiny *c.*1844 pencil sketch of 'Fishermen in Whale Boats' can be found in the *Arnheim Sketchbook.*

6 For more on Franklin, see Andrew Lambert, *The Gates of Hell: Sir John Franklin's Tragic Quest for the Northwest Passage* (New Haven: Yale University Press, 2009). For more on the phases of Victorian Arctic exploration, see Chauncey B. Loomis, 'The Arctic Sublime', in U.C. Knoepflmacher and G.B. Tennyson, eds, *Nature and the Victorian Imagination* (1977), 95–112; 100; and Robert G. David, *The Arctic in the British Imagination, 1818–1914* (Manchester: Manchester University Press, 2000), xvii.

7 David, *Arctic,* 240. For more on Arctic panoramas, see Russell A. Potter, *Arctic Spectacles: The Frozen North in Visual Culture 1818–1875* (Seattle: University of Washington Press, 2007).

8 David Blayney Brown, Amy Concannon and Sam Smiles, eds, *Late Turner: Painting Set Free* (London: Tate, 2014), 60.

9 John Ruskin, *The Works*, Edward Tyas Cook and Alexander D.O. Wedderburn, eds (London: Allen, 1903–12), 3: 251–252; and 13: 167.

10 Sam Smiles, *J.M.W. Turner: The Making of a Modern Artist* (Manchester: Manchester University Press, 2007), 89.

11 For more, see Barry Venning, 'Turner's Whaling Subjects', *Burlington Magazine* 127 (February 1985), 75–83; and Robert K. Wallace, 'The 'Sultry Creator of Captain Ahab': Herman Melville and J.M.W. Turner', *Turner Studies* 5 (Winter 1985), 2–19; 'Teaching *Moby-Dick* in the Light of Turner', in Martin Bickman, ed., *Approaches to Teaching Melville's 'Moby-Dick'* (1985), 135–139; 'The Antarctic Sources for Turner's 1846 Whaling Oils', *Turner Studies* 8.1 (Summer 1988), 20–31; 'Melville, Turner, and J.E. Gray's Cetology', *Nineteenth-Century Contexts* 13 (Fall 1989), 151–176; 'Two Antarctic Vignettes', *Turner Studies* 9 (Summer 1989), 48–55; and *Melville and Turner: Spheres of Love and Fright* (Athens: University of Georgia Press, 1992).

12 For more on Turner's relationship to Bicknell, see John Gage, ed., *Collected Correspondence of J.M.W. Turner* (Oxford: Clarendon, 1980), 205, 219–220, 240, 277; and Peter Bicknell and Helen Guiterman, 'The Turner Collector: Elhanan Bicknell', *Turner Studies* 1 (1987), 34–44. For more on the Bicknell collection, see Anon, 'The Collection of Elhanan Bicknell', *Art Journal* 3 (January 1857), 8–10.

13 John Burnett, *Turner and his Works Illustrated with Examples of His Pictures and Critical Remarks on his Principles of Painting* (London: David Bogue, 1852), 120.

14 Gage, ed., *Correspondence,* 205.

15 Martin Butlin and Evelyn Joll, eds, *The Paintings of J.M.W. Turner* (1977; Rev. 1984; New Haven: Yale University Press, 1984)*,* 237.

16 In *An Account of the Arctic Regions, with a History and Description of the Northern Whale Fishery* (Edinburgh: Archibald and Constable, 1820), Scoresby talks about the 'circumpolar seas' and 'circumpolar regions' (49). The debate regarding the *Slave Ship* has been long and intense. For representative positions, see Albert Boime, 'Turner's *Slave Ship*: The Victims of Empire', *Turner Studies* 10.1 (1990), 34–45; John McCoubrey, 'Turner's *Slave Ship*: Abolition, Ruskin, and Reception', *Word and Image* 14.4 (October–December 1998), 319–353; Marcus Wood, *Blind Memory: Visual Representations of Slavery in England and America, 1780–1865* (New York: Routledge, 2000), 1–78; Jan Marsh, 'Ruskin and Turner's *Slavers*: Patriotic, Political and Pictorial Issues', *Visual Culture in Britain* 2.1 (Spring 2001), 47–65; Tobias Doring, 'Turning the Colonial Gaze: Re-Visions of Turner in Dabydeen's *Turner*', *Third Text* 38 (2008), 3–14; and Sam Smiles, 'Turner and the Slave Trade: Speculation and Representation, 1805–1840', *British Art Journal* 8.3 (Winter 2008), 47–54.

17 Leo Costello, *J.M.W. Turner and the Subject of History* (Aldershot: Ashgate, 2012), 2.

18 Smiles, *Making*, 2.

19 Wallace, 'Whaling', 378–379.

20 David Hill, *Turner's Birds: Bird Studies from Farnley Hall* (Oxford: Phaidon, 1988), 20. For more, see Anne Lyles, *Turner and Natural History: The Farnley Project* (London: Tate Gallery, 1988).

21 Hill, *Turner's Birds*, 4, 9, 18, 20. There may be a suggestive relationship between the studies of decapitated birds' heads and the related image of the sperm whale's head, in the absence of its body, rearing from the water in the Met *Whalers* and suspended from the rigging in *Hurrah! for the Whaler Erebus! Another Fish!'*

22 Hill, *Turner's Birds*, 20.

23 Hill, *Turner's Birds,* 24.

24 Mandy Swann, 'Replenishing the Void: Turner's *Sunset at Sea, with Gurnets*', *The Journal of Ecocriticism* 6.2 (July 2014), 1–17, 1–2, 4.

25 Swann, 'Replenishing', 6–7, 10, 12, 16.

26 Thornbury, *Life*, 2: 123.

27 Swann, 'Replenishing', 6–7, 10, 12, 16.

28 Wallace, *Turner/Melville*, 362.

29 Swann, 'Replenishing', 6–7, 10, 12, 16.

30 Wallace, *Turner/Melville*, 168; 'Whaling', 378.

31 Wallace, *Turner/Melville*, 168.

32 Wallace, *Turner/Melville*, 175–176, 540, 552–555.

33 Wallace, *Turner/Melville*, 573.

34 Venning, 'Turner's Whaling Subjects', 76. For more on Turner's relation to Manby, see James Hamilton, *Turner and the Scientists* (London: Tate, 1998), 84–90, 102.

35 George William Manby, *Journal of a Voyage to Greenland, in the Year 1821, with Graphic Illustrations* (London: Whittaker, 1823), 18, 22, 44, 64.

36 Manby, *Journal*, vi, 129–130.

37 Manby, *Journal*, 24, 125.

38 Manby, *Journal*, vi, viii, 24, 29, 36, 49.

39 Manby, *Journal*, 45, 48, 53, 58, 69.

40 Manby, *Journal*, 55.

41 Manby, *Journal*, 197.

42 Manby, *Journal*, 18, 44, 64, 66, 72–73, 77, 80, 89, 92, 162–163.

43 Wilton, *Sublime*, 26, 97.

44 Venning, 'Whaling', 79.

45 Robert Upstone, *Turner: The Final Years: Watercolours, 1840–1851* (London: Tate, 1993), 16.

46 Hamilton, *Turner and the Scientists*, 126.

47 Upstone, *Turner*, 22.

48 Potter, *Arctic Spectacles*, 159; Loomis, 'Arctic Sublime', 96; Hill, *Turner in the Alps*, 62. For more on Turner and the Alps, see Andrew Wilton and John Russell, *Turner in Switzerland* (Zurich: De Clivo, 1976); David Hill, *Turner in the Alps, 1802* (London: Tate, 1998); and *Le Mont Blanc et la Vellee d'Aoste* (Aosta: Regional Archaeological Museum, 2000).

49 Hokanson, *Turner's Whaling Images*, 6, 14, 17. James Hamilton similarly reads this pictures as concerned with the 'deep ocean' (*Turner: The Late Seascapes* (New Haven and London: Yale University Press, 2003), 92).

50 For more, see Wallace, 'Two Antarctic Vignettes', 48–55.

51 Wilton, *Turner in his Time*, 131.

52 Brown, *Turner in the Alps*, 63.

53 For more, see Hamilton, *Seascapes*, 41.

54 Brown, *Turner and the Alps*, 165.

55 Wilton, *Turner in his Time*, 146.

56 Thornbury, *Life*, 1: 349.

57 J.D. Hooker, 'Summary of the Voyage', in John Richardson and J.E. Gray, eds, *The Zoology of the Voyage of the H.M.S. Erebus and Terror Under the Command of Captain Sir James Clark Ross, R.N., F.R.S., During the Years 1839–1843* (London: Longman's, 1864), ix–x.

58 Wallace, 'Antarctic', 49.

59 Hamilton, *Turner and the Scientists*, 109.

60 Richard S. Owen, *The Life of Richard Owen* (London: John Murray, 1984), 1: 262–264.

61 Beale, *Natural History*, 71–72, 75–76. The Humber whale skeleton can now be found in the Natural History Museum in London.

62 Wilton, *Turner and the Sublime*, 168.

63 Brown, Concannan, and Smiles, *Late Turner*, 154.

64 Eleanor Hughes, ed., *Spreading Canvas: Eighteenth-Century British Marine Painting* (New Haven: Yale University Press, 2016), 169, 178.

65 Hamilton, *Turner and the Alps*, 16; *Turner and the Scientists*, 42. For fuller accounts of Turner's relationship to the industrial revolution, see John Gage, *Turner, Rain, Steam, and Speed*

(London: Allen Lane, 1972); Judy Egerton, *Turner: The Fighting Temeraire* (London: National Gallery, 1995); William S. Rodner, *J.M.W. Turner, Romantic Painter of the Industrial Revolution* (Berkeley: University of California Press, 1997); and David Hill, *Turner and Leeds: Images of Industry* (Huddersfield: Northern Arts, 2008).

66 Hamilton, *Turner and the Scientists*, 74.

67 Peter Bower, *Turner's Papers: A Study of the Manufacture, Selection, and Use of His Drawing Papers, 1787–1820* (London: Tate, 1990), 24–25, 50, 77; and *Turner's Later Papers 1821–1851* (London: Tate, 1991), 32.

68 For more, see T.H. Huxley, 'On a Piece of Chalk', *Macmillan's Magazine* (September 1868), 396–408; Thornbury, *Life*, 1: 362; 2: 74; 282–3; Anthony Bailey, *Standing in the Sun* (London: Harper Collins, 2013), 256, 289; and Sam Smiles, *The Turner Book* (London: Tate, 2006), 178.

69 Brown, Concannon, and Smiles, eds, *Late Turner*, 51, 170–173.

70 Brown, Concannon, and Smiles, eds, *Late Turner*, 51, 170–173, 186.

71 Smiles, *Making*, 145.

72 Bailey, *Standing*, 83.

73 Bailey, *Standing*, 83–84, 86.

Chapter 4

Shopping and Scrimshandering: Whales as Commodity and Craft

Martha Cattell

'*The young fish, as with no consciousness of danger in its unoffending nature, rose near a boat, the harpooner of which knew no distinction or merit in a whale beyond the quantity of oil it would yield; he immediately plunged his weapon into the back, and with the assistance of others, soon killed it and brought it to the ship.*'[1]

George William Manby
Journal of a Voyage to Greenland, in the Year 1821 (1823)

THE
WHALEBONE
MANUFACTORY,
South street, Kingston-upon-Hull

G. R.

By the King's Letters Patent,

The Public is respectfully informed, that Orders are received and executed with the greatest punctuality and dispatch, for

*SIEVES and RIDDLES of every description.

NETS, with Mashes of various Sizes, for folding Sheep, preventing Hares and Rabbits from passing through Enclosures or Pleasure Grounds, or entering young Plantations.

SLAYS, for Weavers.

TRELICES or GUARDS for Shop-windows, Gratings for Granary, Barn, Warehouse, or Cellar Windows.

Ornamental BLINDS, for House Windows, of various Patterns.

CLOTH of great durability for the preservation of Meat, in Larders, or Safes.

BED BOTTOMS, in place of Sacking.

CARRIAGE BACKS and SIDES; CHAIR and SOFA BACKS, and BOTTOMS, in Black, White, or other Colours, after the manner of Cane in any Pattern.

STUFFING, for Chair and Sofa Bottoms and Backs at a lower Price, and preferable to Curled Hair.

BRUSHES, of different sorts. With a variety of other ARTICLES.

John Bateman,
AND
Robert Bowman.

* Extract from the last address to the Board of Agriculture, by Sir John Sinclair, Bart. on the 7th. June, 1808.—"The "Whalebone Sieves, and Nets for confining Sheep, invented by Mr. Bowman, are evidently much more durable, and in "other respects greatly to be preferred, to any article of the same sort now in use. It is certainly desirable also, by increas- "ing the consumption of Whalebone, to promote our fisheries, which, like other branches of domestic industry, cannot be "too much encouraged."

MYRTON HAMILTON, PRINTER, SILVER STREET, HULL.

In 1808, you could purchase the following products from John Bateman and Robert Bowman's Whalebone Manufactory, on South Street, in Hull: 'Sieves and riddles of every description, nets, slays for weavers, trellises or guards, ornamental blinds, carriage backs and sides, stuffing, for chair and sofa bottoms, [and] brushes' (see fig. 4.1).[2] This varied list of objects were all made from baleen, originally found in the suborder of whales *Mysticeti*, and specifically targeted by whalers in the form of the *Balaenidae* family, which included northern Atlantic right whales, north Pacific right whales, southern right whales, and bowheads. Baleen is a keratinous substance that hangs from the roof of the mouths of whales in strips, and is used to strain out krill from sea water, and was referred to often by whalers rather confusingly as *whalebone* (see fig. 4.2).[3] Through the whaling industry, and, as Bateman and Bowman's advert testifies, this substance was employed for a wide variety of utilitarian objects for human use thanks to its flexible and malleable properties.

In addition to baleen, other raw materials rendered from whales included whalebone and also oil, known as spermaceti, which was boiled down from whale blubber or taken directly out of the head of sperm whales (see fig. 4.3).[4] Each whale, dependent on species and size, could contain large quantities of these substances. For example, an average bowhead whale could yield 100 barrels of oil and 3,000 pounds of baleen.[5] The human use of such materials, and the omnipresence of the products created from them, made whales a ubiquitous presence in people's lives, and consciously or otherwise,

Fig. 4.1 Handbill for the Whalebone Manufactory, South Street, Hull, owned by John Bateman and Robert Bowman (1808), printed handbill, 32 x 19.5 cm. © Hull Maritime Museum (KINCM:2005.5322)

late-eighteenth and nineteenth-century consumers would have interacted with their body parts. This might occur through the lighting of lamps or candles typically made from whale oil, such as those provided by Turner's patron, Elhanan Bicknell; by wearing parts of whale carcasses about their bodies in the form of corsets, walking sticks, or crinolines; or by carrying the bodies of dead whales in the form of umbrellas, whose handles and ribs were frequently made from whalebone (see fig. 4.4).

By contrast, interacting with a live whale, beyond its role as a commercial object, would have been impossible for the majority of late-eighteenth- and nineteenth-century viewers. Although the first public aquarium, the 'Fish House' at Regent's Park in London, opened in 1853, offering the public the opportunity to see fish alive in a tank, as opposed to lying dead on a market stall or a plate, whales were obviously too large to be housed in such spaces. However, on occasion, they did become a visual presence in Georgian and Victorian urban space, through a series of strandings:[6] for example, a sperm whale beached on the Holderness Coast, in East Yorkshire, in 1825 (see fig. 4.5); whilst a fin whale was stranded in the River Thames at Deptford, in 1842, where it may have been seen by Turner.[7] Such strandings brought whales directly to British shores and into popular consciousness, and, in both cases, the whales' bodies were capitalised on and put on display for a paying audience, with the

Fig. 4.2 Baleen Plate (date unknown), whale baleen, 109.2 x 43.2 cm. © Hull Maritime Museum (KINCM:2005.2493)

Fig. 4.3 (inset) Sperm Oil (date unknown), sperm oil, 14.8 x 6.5cm. © Hull Maritime Museum (KINCM:1957.72.4)

SPERMACETI WHALE, Length 58 feet 6 inches Cast on the HOLDERNESS COAST.
28. April 1825.

Holderness whale being described in a local press article from the *Hull Rockingham,* in 1825, as 'an object of intense curiosity to the surrounding country'.[8] To this day, visitors are still able to see the remains of the Holderness whale at Burton Constable Hall in Yorkshire, where its skeleton is currently on display in one of the stables, and described on its website as being a '60-foot monster' – a phrase still perpetuating its curiosity.[9]

Fig. 4.5 (above) Spermaceti whale (1825), lithograph, 27 x 38 cm. © Hull Maritime Museum (KINCM:1981.811)

Fig. 4.4 Umbrella or parasol frame (date unknown), wood, bone, brass, and elephant ivory, 69.7 x 3.5 cm. © Hull Maritime Museum (KINCM:2011.217)

Indeed, even those who actually went whaling would only partially experience live whales, when they breached above the water; submarine views, where whales could be seen in their natural environment, were not possible until nearly the end of the nineteenth century with the invention of various new technologies. For example, Louis Boutan took the first underwater photographs in 1893, whilst diving. In 1914, meanwhile, John Ernst Williamson shot the first underwater motion picture. The first recordings of so-called 'whale song' were not made until the 1960s.[10] As interaction with whales was rare in long-nineteenth-century Britain, they were most often

Fig. 4.6 (above) Snuff box (1665), horn, cedar wood, walrus bone, 1.2 x 8.7 x 6.8 cm.
© Hull Maritime Museum (KINCM:2005.2315)

Fig. 4.7 Whale tooth pick holder, bone, 10.4 x 3.3 cm. © Hull Maritime Museum (KINCM:2005.2427)

experienced as raw materials or commodities, sold by the likes of Bateman and Bowman, or, as Manby's quotation at the start of this chapter suggests, conceptualised in terms of the 'quantity of oil' they 'would yield'.[11]

Aside from the commercial capital associated with the raw materiality of whales, surplus bone, baleen and ivory were often distributed amongst whaling crews, so that they could be carved and crafted into a variety of objects for on-board or domestic use, in an act known as *scrimshandering*. This was particularly prominent amongst American whaling crews, where longer voyages to the Pacific, sometimes lasting three to four years, were necessary, leaving more spare time for such activities, in which all hands on board were often employed.[12]

In the process of carving scrimshaw, whalebones and teeth were transmogrified by sailors, from organic living matter into a potent souvenir of the hunt or voyage. Etymologically, the exact origin of the term 'scrimshandering' is unknown, and the process of carving on whalebone frequently appears written in other guises in journals and logbooks – colloquial phrases such as schimshank, scrimshader, scrimshant and scrimshone that grew out of the industry itself.[13] Although the term scrimshaw is most associated with nineteenth-century whaling, bone carving in a broader sense was a technique with a long heritage dating back to at least the early Medieval period in

Fig. 4.8 (inset) Faroese knife (date unknown), jawbone, sperm whale tooth, and brass, 31.1 x 4.4 cm. © Hull Maritime Museum (KINCM:1981.71)

Fig. 4.9 Sperm whale tooth (date unknown), 15.8 x 5.6 cm. © Hull Maritime Museum (KINCM.1999.200.66)

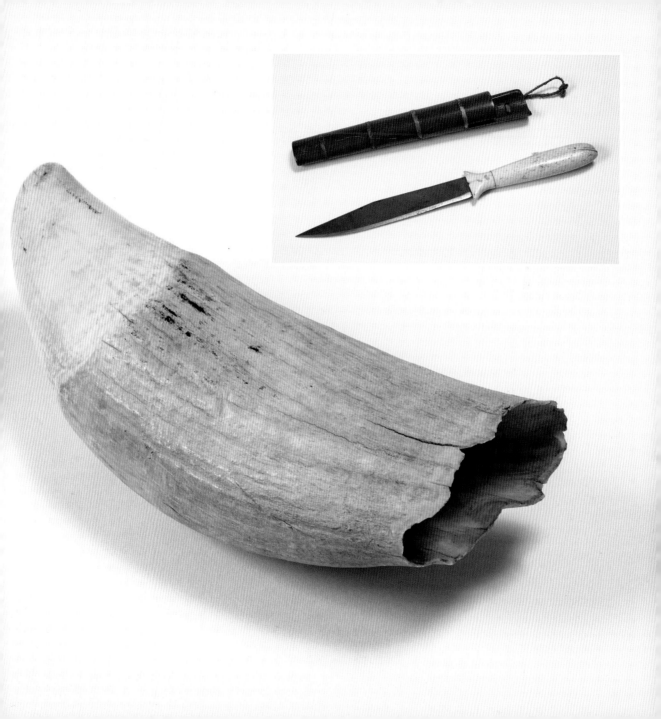

Europe, and was also practised by indigenous populations in the Arctic circle, as well as by prisoners in prisoner-of-war camps where chicken or other animal bone was used, with varying relationships between person and animal established in the process of creating each object.[14]

Hull Maritime Museum has one early example from 1665, a small snuff box inlaid with walrus ivory (see fig. 4.6). The box features stippling around the lid, and reads 'Either love mee or love mee not'. Scrimshandering is also a tradition that has continued into modern times, including a small cocktail stick holder (c.1970), again in the Hull collections, where once consumers have finished picking food from between their teeth, they could plunge the small implement, like a micro-harpoon, into the back of a diminutive whale (see fig. 4.7). The holder is clearly meant to be playful, and the reduction of scale renders the brutality of the act less violent, but a violence undoubtedly remains; a violence against animals all the more apparent if what is being picked out from the consumer's teeth is a piece of meat or fish.

A Faroese knife used in pilot whale drives is a second modern example (see fig. 4.8). Targeted for their meat, the spines and arteries of pilot whales are cut on shore, after the whale has been driven there by members of the local population, in a hunt known as *grindadráp*. The handle of the knife is made from jawbone with a cross-piece of sperm whale tooth, and it is carved in the shape of a pilot whale, with details of its dorsal fin, eye and mouth; a motif violently acknowledging the trade the tool would be employed in.[15]

The most significant scholarly contributions to the literature on scrimshaw so far are E. Norman Flayderman's *Scrimshaw and Scrimshanders: Whales and Whalemen* (1972) and Stuart Frank's *Ingenious Contrivances, Curiously Carved: Scrimshaw in the*

PULLING TEETH

Fig. 4.10 Francis Allyn Olmstead, 'Pulling Teeth', in *Incidents of a Whaling Voyage* (New York: Appleton, 1841).

New Bedford Whaling Museum (2012). Both catalogue the medium, giving illustrated and written descriptions of its various incarnations and narratives.[16] Yet there is still more work to be done on the subject, especially in relation to what it might mean to rethink pieces of scrimshaw from both a critical animal studies perspective, one sympathetic to the views of vegetarians and vegans, and from the perspective of gender and sexual politics.[17]

The main materials that were used to create scrimshaw included whale jawbones, known as pan-bone, baleen, and sperm whale teeth. In scrimshandering, the whalers were not just employing pieces of neutral raw material, but the bodies of dead whales, alongside other marine mammal products including dolphin jaws, walrus tusks and narwhal horns. Sperm whale teeth were particularly popular in the long nineteenth

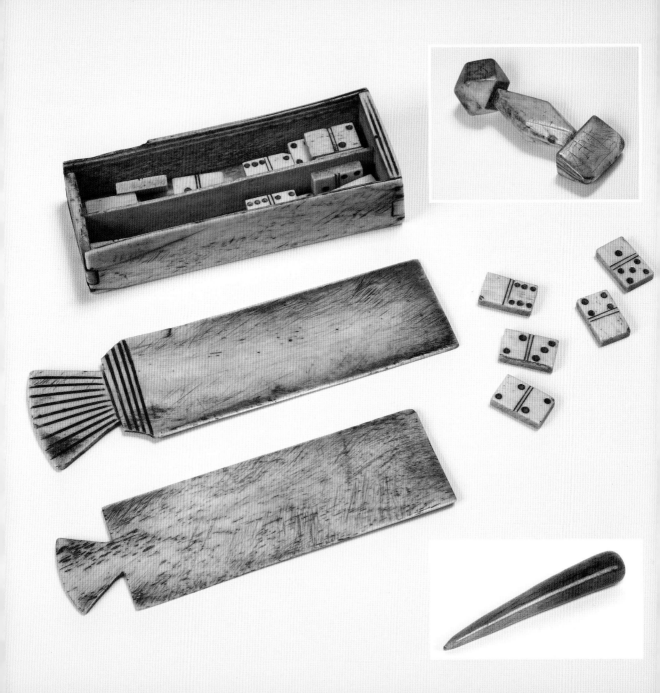

century, and each fully grown adult whale would have had, on average, a single set of between 40 and 50 large teeth in the bottom jaw, which could reach a length of around 20cm (see fig. 4.9). Some teeth were also present in the upper jaw, but they would often fail to break through. These teeth would have to be extracted from the sperm whale's jaw, in a process depicted by Francis Allyn Olmstead in *Incidents of a Whaling Voyage from 1841* (1841), which described the extraction process as being akin to 'the practice of dentistry on a grand scale' (see fig. 4.10).[18]

After being distributed amongst the crew, the teeth would be prepped ready for carving. This would involve soaking the teeth in liquids such as hot water and lye, and then sanding them down with paper or shark skin, to rid the teeth of their natural ridged and worn surface, in effect domesticating them for human use.[19] Teeth were then cut, pierced or engraved, with tools such as sailing needles or a jackknife, or, in some instances, as Herman Melville states in *Moby-Dick* (1851), 'dentistical-looking implements, specifically intended for the skrimshandering business'.[20] Each up and down motion applied by one of these tools would remove tiny ivory or bone shavings; a removal of substance that would literally embed the whaler's emotions and narrative

Fig. 4.11 Domino set (date unknown), bone, 14.5 x 4.4cm x 2.3 cm. © Hull Maritime Museum (KINCM:1980.813)

Fig. 4.12 (bottom inset) Fid (c.19th century), whale jawbone, 29 cm long. © Hull Maritime Museum (KINCM:1993.130)

Fig. 4.13 (top inset) Seam rubber (c.19th century), whale ivory, 11.8 x 4.2 x 3 cm. © Hull Maritime Museum (KINCM.1986.1727)

onto the surface. Colourants were also often used to bring out the etchings. This was done by rubbing substances, such as lampblack or Indian ink, onto the teeth before they were polished with a pumice or wax to produce a shiny finish.[21]

Whaling was a largely masculine industry, with little evidence of women's involvement, beyond the wives of captains and their first mates occasionally joining their husbands on board. However, even those women who did venture on board were typically restricted to domestic tasks such as cooking, cleaning and teaching, and were most emphatically forbidden from partaking in the mass brawl of the whale hunt.[22] This meant that men were almost certainly responsible for nearly all the scrimshaw that survives from long-nineteenth-century whaling; a fact reflected in the designs, as we shall see. Functional objects made from whalebone, meanwhile, could range widely from domino sets (see fig. 4.11) and ditty boxes to more practical objects for use on board such as fids (see fig. 4.12), used for making holes in sails and tarpaulin, and untangling lines of rigging; and also seam rubbers (see fig. 4.13), used for smoothing certain materials such as sailcloth and whalers' clothes.[23] There were also a great many items crafted by whalers that were intended for domestic use by the mothers, wives, sisters, friends and lovers at home, including pie crimpers and pastry rollers, used to add patterns or to cut the top of pastry (see fig. 4.15); and swifts, for winding yarn (see fig 4.16). These were typically made of pinned-together jawbone pieces, and, when fully outstretched, appear almost skeletal in their form.[24]

Fig. 4.14 Seaman's tidy box (c.19th century), wood, brass and whalebone, 14.6 x 30 x 20 cm. © Hull Maritime Museum (KINCM:1978.87)

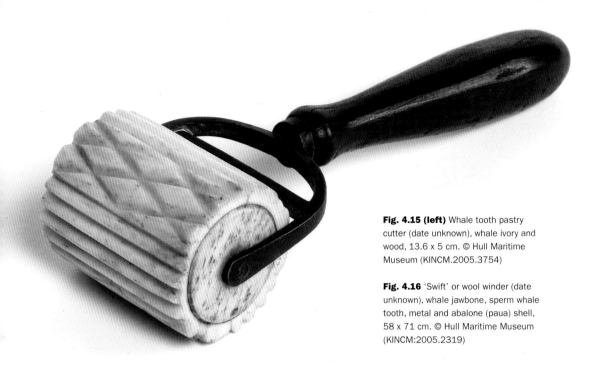

Fig. 4.15 (left) Whale tooth pastry cutter (date unknown), whale ivory and wood, 13.6 x 5 cm. © Hull Maritime Museum (KINCM.2005.3754)

Fig. 4.16 'Swift' or wool winder (date unknown), whale jawbone, sperm whale tooth, metal and abalone (paua) shell, 58 x 71 cm. © Hull Maritime Museum (KINCM:2005.2319)

Perhaps the most potent example of this category of scrimshaw, however, was the busk, which formed a key part of the corset (see fig. 4.17). Busks were often decorated with geometric patterns or featured initials, presumably of the woman wearing them or the whaler carving them, or both. As well as the initials 'A.R.', enclosed in a lozenge-shaped form, an ornately coloured example in the Hull collections includes, alongside various decorative elements, a swan, a small fortification, a cottage and a ship (see fig. 4.18). Such busks would be pressed against the bosom; an intimate, but constraining physicality, which would both remind wives and girlfriends of the touch of the whaler, and act as to keep those same women's bodies tightly constrained whilst the sailors were away.

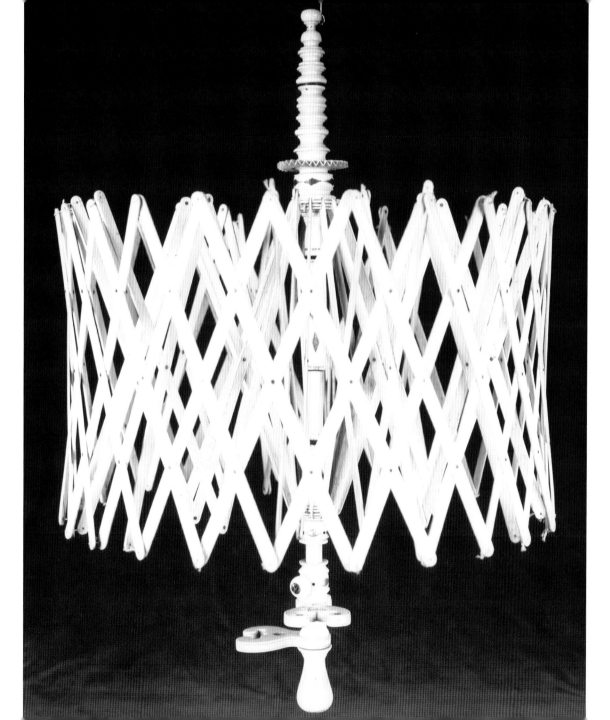

There was a wide variety in decorative terms, but popular motifs included ship portraits and naval scenes (see fig. 4.19). Another example from the Hull collections shows two full-rigged ships, viewed in starboard, engaged in a foray. Victory is close for the foremost vessel, as a cannon smashes into its opponent, causing its mizzen-mast to fall. Nationalistic flags and figures were also popular and can be found in various guises. For example, images of Britannia were predictably popular on British scrimshaw, and they were sometimes engraved as a small detail on a scrimshaw busk (see fig. 4.20). Recognisable by her seated form and shield, Britannia here also flies the royal ensign on her trident – a flag flown to identify a British military or civilian ship.

Whaling scenes were also popular, especially on pieces of pan bone.[25] For instance, one example (see fig. 4.21) shows two spouting bowhead whales, identifiable by their distinctive pair of blowholes and lack of dorsal fins. On the left of the image, one whale lurches out of the water with a harpoon in its back, as a cloud of blood emits from its blowholes, and water leaks out from between its baleen plates. The other whale, on the right, is just visible above the surface and has suffered a similar fate, with the raised flag on the whaleboat emphasising that a catch has been made. In the background, a whale ship waits, with a pair of crudely etched icebergs, denoting the Arctic setting. The magnitude of such an act, with a fully grown adult male

Fig. 4.17 Whalebone corset (1760–80), whalebone, 46 cm high. © Hull Maritime Museum (KINCM:2005.2455)

Fig. 4.18 (right) Decorated scrimshaw busk (c.19th century), 36.5 x 6 cm, whale jawbone. © Hull Maritime Museum (KINCM:1978.22)

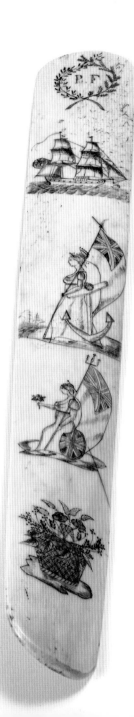
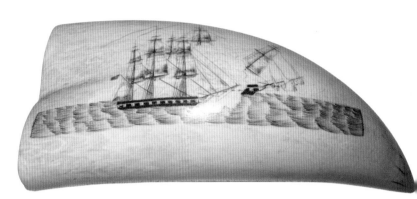
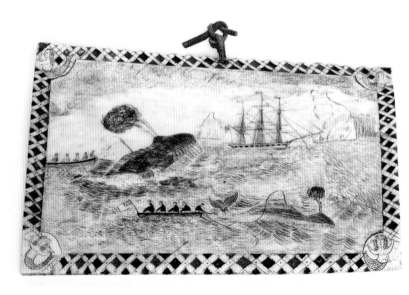

bowhead averaging around 50 feet in length and weighing around 60 tons, is here rendered diminutive and decorative, through a reduction in scale.[26]

Similar depictions of sperm whale hunting occur on sperm whale teeth (see fig. 4.22). Engraved onto a further example from the Hull collections is a full-rigged ship, which surveys the scene as three whaleboats are engaged in killing two sperm whales, on the left. One raises its giant head, as blood, vividly marked in red, discharges from its body. On the right, whalers raise their oars in celebration as a sperm whale floats, dead in the water, its state signalled by a waif (small flag) sticking out of its body. Turning the tooth 90 degrees reveals the image of a sperm whale carved along the length of the tooth, directly underneath the whaling scene, here indicating both the bounty and scale of the catch. These etched whaling scenes would, most likely, have been created by the whalers on board ship, and so a steady hand would have been needed to prevent slippage caused by the rhythms of the sea. Unlike the formally and morally complex depictions of the whale hunt by Turner and most members of the Hull School of painters, this representation most likely draws on a direct and visceral first-hand experience of whaling, and scrimshaw leaves viewers with little doubt as to

Fig. 4.19 (top right) Sperm whale tooth with naval battle decoration (date unknown), sperm whale tooth, 17.6 x 8 cm. © Hull Maritime Museum (KINCM:1999.200.1)

Fig. 4.20 (far left) Scrimshaw busk with detail of Britannia (date unknown), whale jawbone, 35.2 x 4.8 cm. © Hull Maritime Museum (KINCM:2005.2337)

Fig. 4.21 (bottom right) Whalebone plaque (date unknown), whale jawbone, 13 x 20.5 cm. © Hull Maritime Museum (KINCM:1975.24)

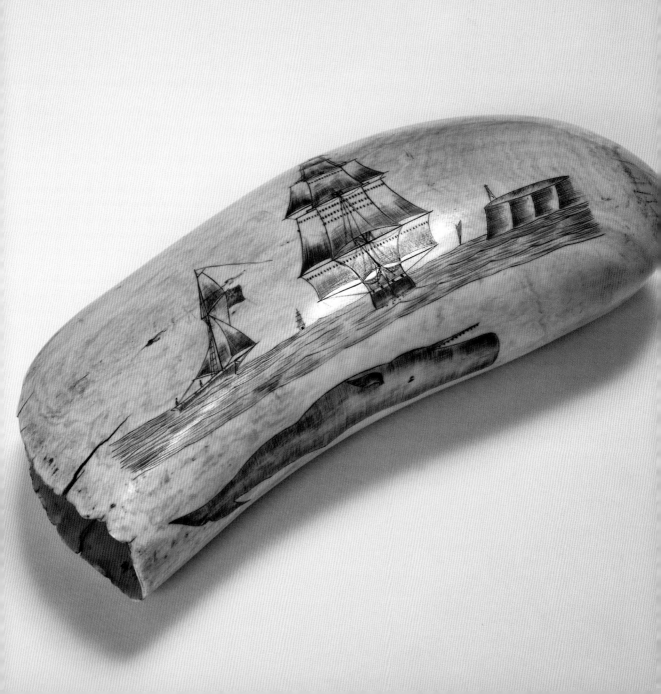

what the artist thought; an inscription on a sperm whale tooth proclaims 'Death to the living / Long life to the killers / Success to Sailors' Wives & / Greasy Luck to the Whalers'.[27]

The most popular subject produced by whaler craftsmen was, however, women. In the absence of any, or at least many, actual women, these carved images were often depicted in idealised or perfected forms, and frequently derived from fashion plates, reflecting both how the length of a voyage would blur together ideas of the real and ideal, and the fact that whalers would have had frequent thoughts of home and female company; an exciting or melancholy internal escape from the monotony of the long voyages and the stench of vessels saturated with the detritus of whales.[28]

For example, one tooth, decorated on two sides (see fig. 4.23), features on one side a whaling scene, showing a fully rigged barque etched on the left of the tooth. A number of men in whaleboats, in the right foreground, aim to attack a pod of sperm whales, visible in various stages of distress. The sea is suggested by a series of small indents probably made by a jackknife. When the tooth is turned over, however, it reveals another carved image on the reverse. Here we find a faint depiction of a woman, with her features just visible on the surface of the tooth; her curled hair falls about her face, and she is clothed in fashionable dress (see fig. 4.24). In addition to the optical dynamics of this tooth, which reflect the dichotomy of the on-shore/ship-bound life

Fig. 4.22 Scrimshaw tooth with detail of whaling scene (c.19th century), sperm whale tooth, 19.5 x 7 cm. © Hull Maritime Museum (KINCM:1939.4)

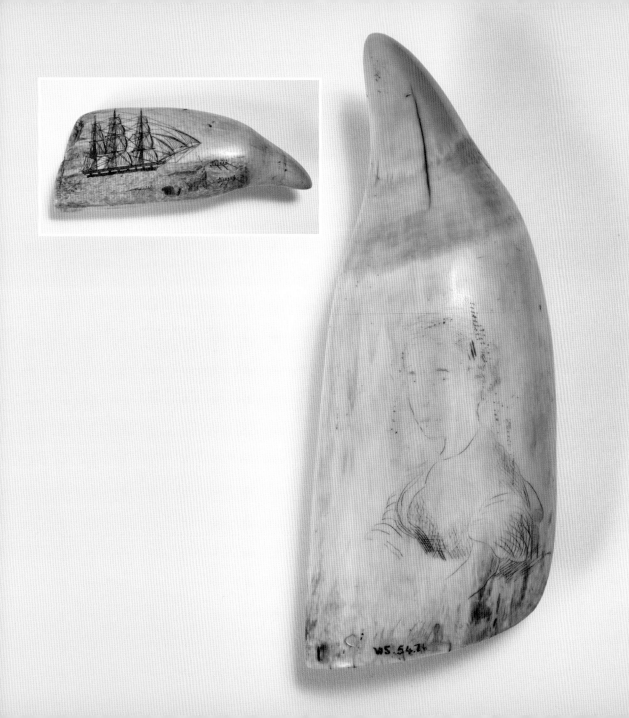

of the whaler, the tactility of the tooth is also important. It would be a stimulus in, and to, the whaler's hands as he crafted the object, and also later, as he was able to turn the tooth in his hand, to feel its weight and the lines engraved upon it, to remind himself both of the reason for being on board, and the reason to get home; a tactility mostly lost through the museum experience, where glass cabinets prevent any form of physical interaction. In this example, the image of the woman is fainter than that of the whaling scene, suggesting, perhaps, that the portrait had been frequently touched or rubbed, as if, in some small degree, the whaler was trying to replicate an intimacy with the woman depicted, whilst also being reminded, through the weight and feel of the whalebone, of the very animal that was responsible for the separation in the first place.

The bodies of dead whales, then, became not just raw materials for commercial gain, but vessels for the thoughts and feelings of the whalers and those they left behind, encouraging us, as we contemplate their imagery, crafting and reception, to think further and harder about both men's relationships to women and humans' relationship to animals across the long nineteenth century.

Fig. 4.23 (inset) Whaling scene detail on scrimshaw tooth (date unknown), sperm whale tooth, 18.5 x 7 cm. © Hull Maritime Museum (KINCM.1979.72)

Fig. 4.24 Portrait of woman detail on scrimshaw tooth (date unknown), sperm whale tooth, 18.5 x 7 cm. © Hull Maritime Museum (KINCM.1979.72)

ENDNOTES

1 George William Manby, *Journal of a Voyage to Greenland, in the Year 1821* (London: G. and W.B. Whittaker, 1823), 47.

2 'The Whalebone Manufactory, South Street, Kingston upon Hull', reprinted in Peter Adamson, *The Great Whale to Snare: The Whaling Trade of Hull* (Hull: Hull Museums and Art Galleries, 1974), 8.

3 Hal Whitehead and Luke Rendell, *The Cultural Lives of Whales and Dolphins* (Chicago: University of Chicago Press, 2015), 147.

4 Janet West and Arthur G. Credland, *Scrimshaw: The Art of the Whaler* (Hull: Hull City Museums and Art Galleries and Hutton Press, 1995), 9.

5 Norman E. Flayderman, *Scrimshaw and Scrimshanders: Whales and Whalemen* (New Milford: Flayderman and Co., 1972), 18.

6 Diana Donald, *Picturing Animals in Britain, 1750–1850* (New Haven: Yale University Press, 2007), vii. See also Louis Lippincott and Andreas Bluhm, 'From Meat to Metaphor', in *Fierce Friends: Artists and Animals, 1750–1900* (London: Merrell, 2005), 114.

7 For more on the whale washed up on Holderness Coast, see 'The Whale', *Hull Rockingham* (14 May 1825), 3; and on the whale that appeared at Deptford, 'A Whale Species in the Thames', *Illustrated London News* (29 October 1842), 388. For Turner's relationship to the latter, see James Hamilton, *Turner: A Life* (London: Sceptre, 1997), 297.

8 'Stranded Whale', *Hull Rockingham* (7 May 1825), 3.

9 'Burton Constable homepage', *Burton Constable*, http://www.burtonconstable.com/ (Date of Access: 3 January 2017).

10 William Thomson is often credited with having created the first underwater images in 1856, by submerging a camera on the end of a pole, but here reference to the first images produced by divers seemed more appropriate. For more, see Nick Robertson-Brown, *Underwater Photography: Art and Techniques* (Marlborough: Crowood, 2014). The first whale to be recorded, by the US Navy, in the 1960s was the humpback. In 1970, *Songs of the Humpback Whale* swept the charts, transforming people's perceptions of whales and their culture. For more on whale song, see Whitehead and Rendell, *Cultural Lives of Whales and Dolphins*; and David Rothenberg, *Thousand Mile Song* (London: Perseus, 2008).

11 Manby, *Journal of a Voyage,* 47.

12 For more information on American whaling, see Margaret S. Creighton, *Rites and Passages: The Experience of American Whaling, 1830–1870* (Cambridge: Cambridge University Press, 1995); and Eric Jay Dolin, *Leviathan: The History of Whaling in America* (New York: Norton, 2007).

13 Flayderman, *Scrimshaw and Scrimshander*, 3–14.

14 For more, see Carson I.A. Ritchie, *Modern Ivory Carving* (South Brunswick: A.S. Barnes, 1972); and, more broadly, West and Credland, *Scrimshaw: The Art of the Whaler*, 83; Flayderman, *Scrimshaw and Scrimshanders*, 243–278; and Alfred Maskell, *Ivories* (Vermont: Charles E. Tuttle, 1966).

15 For more, see J.N. Tønnessen and Arne Odd Johnsen, *The History of Modern Whaling* (Berkeley: University of California Press, 1982); and Robert C. Rocha, junior, Phillip J. Clapham, and Yulia V. Ivashchenko, 'Emptying the Oceans: A Summary of Industrial Whaling Catches in the 20th Century', *Marine Fisheries Review* 76.4 (2015), 37–48.

16 For further examples, see Richard C. Malley, *Graven by the Fishermen Themselves: Scrimshaw in Mystic Seaport Museum* (Mystic: Mystic Seaport Museum, 1983).

17 For a representative example, see Erica Fudge, 'Renaissance Animal Things', *New Formations* 76 (Summer 2012), 86–100.

18 Francis Allyn Olmsted, *Incidents of a Whaling Voyage* (New York: Appleton, 1841), 181–182.

19 Flayderman, *Scrimshaw and Scrimshanders*, 4.

20 Herman Melville, *Moby-Dick* (1851; New York: Penguin, 1992), 258.

21 Frank, *Ingenious Contrivances*, 153.

22 For more on the crucial role of women in the whaling industry, see Joan Druett, *Petticoat Whalers: Whaling Wives at Sea, 1820–1920* (Auckland: Collins New Zealand, 1991); and Lisa Norling, *Captain Ahab had a Wife: New England Women and the Whalefishery, 1720–1870* (Chapel Hill: University of North Carolina Press, 2000).

23 Frank, *Ingenious Contrivances*, 165–167.

24 West and Credland, *Scrimshaw*, 69.

25 West and Credland, *Scrimshaw*, 23–27, 39–43.

26 'Bowhead Whales', *American Cetacean Society*, http://acsonline.org/fact-sheets/bowhead-whale/ (Date of Access: 8 January 2017).

27 Engraving on 'Susan's Tooth', Hull Maritime Museum Collection, Hull.

28 Norling, *Captain Ahab*, 435.

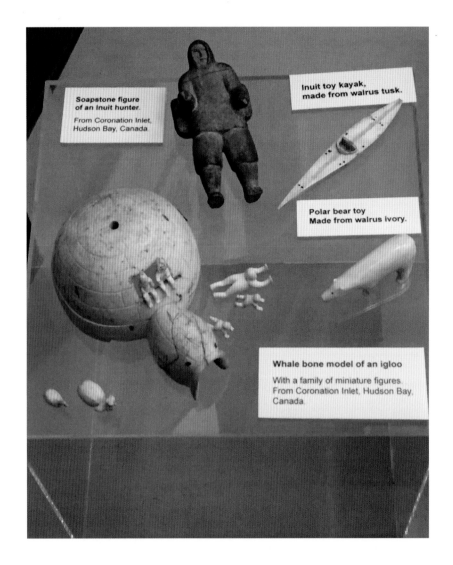

Soapstone figure
of an Inuit hunter.

From Coronation Inlet,
Hudson Bay, Canada.

Inuit toy kayak,
made from walrus tusk.

Polar bear toy
Made from walrus ivory.

Whale bone model of an igloo

With a family of miniature figures.
From Coronation Inlet, Hudson Bay,
Canada.

Chapter 5

Exploring Frozen Worlds: Inuit Art in the Hull Maritime Museum

Meg Boulton

The Hull Maritime Museum houses an extraordinary collection of objects that allow visitors to glimpse maritime history across a vast period of time, reflecting various aspects and moments of the city's complex relationship with the sea. These objects include a fascinating collection of whaling artefacts and art works relating to the hunting of Arctic mammals: the intriguingly gruesome tools and vessels of the defunct whaling industry

Fig. 5.1 Inuit group of carved figures: Inuit carved from soapstone, igloo and figures carved in whalebone, kayak and bear carved from walrus ivory. Carved in Coronation Inlet, Hudson Bay, in the early 19th century, now displayed in the Hull Maritime Museum (photo: Meg Boulton).

that helped shape the city's identity; a significant collection of intricately carved scrimshaw; and impressive zoological specimens brought home from foreign shores, or, in the case of at least one artefact, washed up on the shores of the Humber.

Of these latter artefacts, perhaps the most iconic are the whale skeletons that dwarf the space of the museum, orienting the flow of visitors around their displayed forms, and disorientating our experience of 'earth', 'sea' and 'sky' as the first appears overhead in a corridor as visitors enter the exhibition space. Along with these monumental, architectural skeletons are other specimens of fauna brought back from the Arctic world by the whalers and explorers who travelled to these remote regions in search of their leviathan prey and a north-west passage to India. It is here, amid the harpoons and flenses that were the tools of the whaling trade, and among the preserved animal forms of the Arctic, that visitors discover the collection of Inuit artefacts belonging to the museum. They are usually displayed in a glass case placed adjacent to the vast, cavernous space of a whale carcass and the massive white bulk of a taxidermied polar bear. These Inuit works are significant and complex, bringing to the collection a different experience of inhabiting the Arctic from that of the Hull whalers, and the painters who imagined their experiences. However, they are here – present in the Maritime Museum – *because* of that trade; indeed, in some cases, they were made expressly for the whalers.

The official museum label identifies these carvings (see fig. 5.1), made of whalebone and walrus ivory (morse), as 'Eskimo Toys, with hinged igloo, probably brought back to Hull by early 19th-century Whalers'.[1] We know, because it is inked onto the bottom, that the igloo, along with its miniature inhabitants, was carved in Coronation Inlet, Hudson Bay. The figures of igloo and Inuit are made of whalebone, and are

displayed in a group along with other sculpted forms common to Inuit carving. These include a water bird, a bear and a kayak (see fig. 5.2), at least two of which are made of walrus ivory,[2] in addition to a hard-to-identify figure that may correspond to the iconographic form of a sea spirit (see figs 5.3, 5.4 and 5.5).[3]

I will return to these carvings shortly, but, first, it is necessary to consider, in more detail, the people and place that produced these remarkable works, in as far as we can look back to a lost world and a distant past, given that our modern gaze is a filtered one affected by temporal differences, by varied experiences, by post-Colonial understandings, and by disparate traditions. Moreover, our scholarly understanding of these works is limited by a lack of archival material relating to their acquisition in the museum, and by the indeterminacy of their making. Are these 'toys', crafted as trinkets for trade or sale with the whaling vessels whose advent disrupted the traditional Inuit rhythms, opening up new avenues of trade and travel? Or, are they also the symbolic totems of place, themselves now placeless, presented in this museum context?

To look at Inuit carving is a complex endeavour, especially items made in the post-contact period when many such works were deliberately created for a European audience; a fact acknowledged from the early days of ethnographic and anthropological scholarship,[4] as well as in more contemporary discussion.[5] The experience is made more complex still, as, although there was a trade market for such carvings, they nonetheless contain referents to traditional motifs rooted in a way of life and a place far removed from post-enlightenment European experiences, but typical of the experience and vision of pre-contact Inuit culture.

Dorothy Jean Ray acknowledges this uniqueness in her large-scale study of Eskimo Art (although she is referring to the visual and material culture of the peoples of

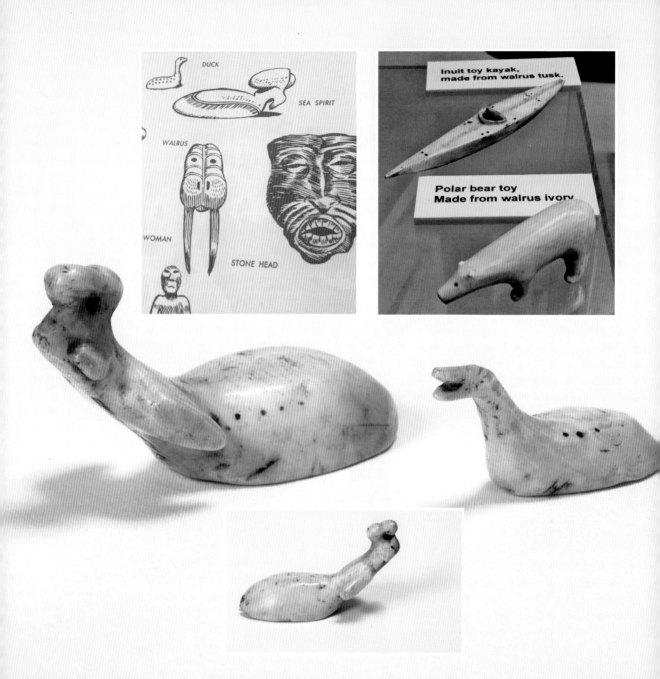

DUCK

SEA SPIRIT

WALRUS

STONE HEAD

WOMAN

Inuit toy kayak,
made from walrus tusk.

Polar bear toy
Made from walrus ivory

Alaska, rather than the Canadian Inuit responsible for the sculpture in the Hull collection). Ray writes that 'the Eskimo … lived within, around, beneath and on the animals they caught, which provided their warmth, protection, sustenance, and materials for art'. These included seals, walruses, caribou and whales, which 'came and went with the seasons or with the weather'.[6] This symbiotic interrelationship between Inuk and nature, human and animal, hunter and prey – bound by temporal rhythms and chance seasons of feast and famine – was fundamental to Inuit culture.[7] This relationship is manifest in the nomadic, seasonal way of life of the Inuit; their cosmological beliefs; and the artistic forms they made – from ceremonial masks to small-scale sculpted works reflecting the natural world, such as those in the Hull collections, which viscerally articulate their social and cultural engagement within this environment.[8]

Fig. 5.2 (top right inset) Kayak and bear carved from walrus ivory. Carved in Coronation Inlet, Hudson Bay, in the early 19th century, now displayed in the Hull Maritime Museum (photo: Meg Boulton).

Fig. 5.3 (top left inset) Detail of an overview of Inuit iconographic types produced for a publication on Canadian Eskimo Art published by the Canadian Government's Department of Northern Affairs and National Resources in 1956. For the full range of these types see James A. Houston, *Canadian Eskimo Art* (Ottawa: Edmond Cloutier, 1956), 6.

Fig. 5.4 (bottom inset) Inuit carved figure, possibly of a sea spirit. Carved in Coronation Inlet, Hudson Bay, in the early 19th century, now displayed in the Hull Maritime Museum. © Hull Maritime Museum (2007.1400.1 07)

Fig. 5.5 Inuit carved figures, possibly of a sea spirit and water bird. Carved in Coronation Inlet, Hudson Bay, in the early 19th century, now displayed in the Hull Maritime Museum. © Hull Maritime Museum (2007.1400.1.2 01)

If they are to be understood, such artistic forms cannot be fully divorced from their context, despite the manifold dislocation of our encounter with them today. Early anthropological studies ranging from the initial observations of E.W. Nelson, through the work of Danish Eskimologist Kaj Birkut-Smith, to the immersive anthropological study carried out by Hans Himmelheber, as well as the extensive art-historical studies produced by Ray, all agree that place is intrinsic to Inuit culture; that the Arctic, with its privations and isolation 'resulted in an almost extravagant perfection of Eskimo culture'.[9] Moreover, this connection is powerfully seen in the work itself. Indeed, the wider association between place and identity is one that is widely observed across times and cultures – place forms us, shapes us. We adapt to it, as much as we shape it. The extent of human engagement with place is undeniable, indeed perhaps increasingly so, but its traces on us, on our identities, are equally important.[10]

In the case of the Inuit artefacts in the Hull collection, place is the Canadian Arctic; a place of increasingly sparse resources and extreme conditions. Inhabiting the periphery of this harsh world meant Inuit developed skills that enabled them to become great open-water and winter-ice marine mammal hunters, becoming both adaptive and resourceful in their relationship to the landscape and its animal inhabitants. Nineteenth-century Inuit were largely nomadic hunters, following seasonal game across their territory (see fig. 5.6). They hunted with harpoons, fish spears, and beautifully crafted stone and bone tools, many of which were well suited

Fig. 5.6 Inuit figure carved in soapstone. Carved in Coronation Inlet, Hudson Bay, in the early 19th century, now displayed in the Hull Maritime Museum. © Hull Maritime Museum (2007.1398 02)

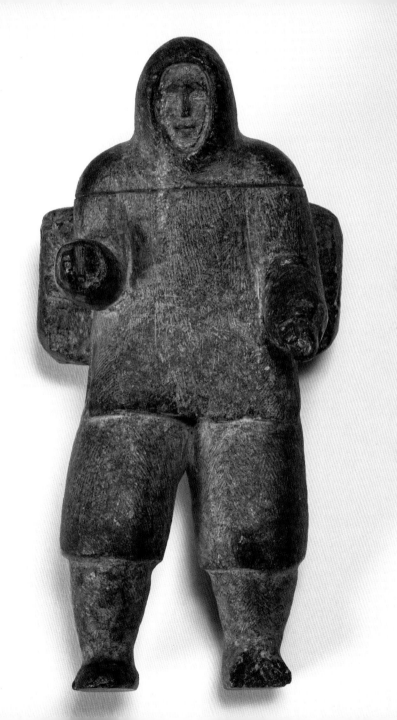

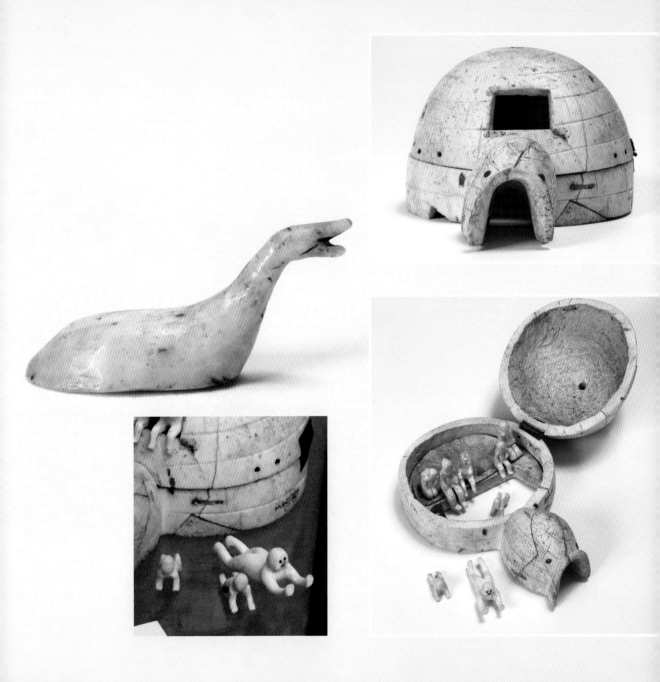

for carving in addition to their other purposes. Indeed, the skills belonging to this hunting culture – those of patience, close observation of animals and their habits and habitats, and being able to endure prolonged and patient exposure to the natural world – were the same skills that allowed Inuit to make such expressive and powerful carvings, which record and describe their world.[11]

Place, then, may be understood to be crucial to the creation of these works which, imbued with the identity and spirit of the thing that is carved, powerfully respond to the essence of the thing they represent, despite their relatively small scale. In this tradition of making, no two carvings are alike; each subject is unique to the carver and to his experience of the world.[12] Although repeated 'types' are found throughout Inuit art, these aren't straightforward copies but are specific to the artisan and the moment of making: 'one … finds beauty in the light sleek lines of the weasel. Another sees the massive bulk of the walrus. Another tries to capture in stone the sullen treachery of a bear. They watch an infinity of detail, then, perhaps, discard all but the essence of the form.'[13]

Fig. 5.7 Inuit carved figure of a water bird. Carved in Coronation Inlet, Hudson Bay, in the early 19th century, now displayed in the Hull Maritime Museum. © Hull Maritime Museum (2007.1400.2 04)

Fig. 5.8 (top inset) Inuit carved igloo. Carved from whalebone in Coronation Inlet, Hudson Bay, in the early 19th century, now displayed in the Hull Maritime Museum. © Hull Maritime Museum (2007.1397 13)

Fig. 5.9 (bottom right inset) Inuit carved igloo, interior. Carved from whalebone in Coronation Inlet, Hudson Bay, in the early 19th century, now displayed in the Hull Maritime Museum. © Hull Maritime Museum (2007.1397 07)

Fig. 5.10 (bottom left inset) Anonymous humanoid form, carved in Coronation Inlet, Hudson Bay, in the early 19th century, now displayed in the Hull Maritime Museum (photo: Meg Boulton).

As noted, whilst such objects are frequently small, scale is not a defining factor for the potency of an artwork. Miniature forms as well as massive works can carry a resonance for viewers out of proportion to the size of the work. Indeed, there is something about the tiny carvings in the Maritime Museum that is powerful and wistful, and, despite their miniature scale, they remain somehow monumental.

The carved group that I am focussing on in this essay contains some of the archetypal forms found across Inuit art, as we have seen, such as the kayak, the bear, and the water bird (see fig. 5.7). This avian creature is a lovely typological example of such forms, characteristically cut off at the imagined line where its body would emerge from the water, as is typical for aquatic animals in this artistic tradition. As a result, the small figure carries around it the negative space and expanse of its aquatic environment through its spatial presence. Such carvings are all totemic, iconic forms, seen over and over again in the surviving corpus of Inuit work.

The igloo is exceptional, presenting both the inside and outside of this sheltering place, allowing viewers to enter the house and to view it from within and without, giving an overview of Inuit environment, and an intimate insight into it (see figs 5.8 and 5.9). Two of the forms are more puzzling than the rest. There is a larger humanoid form with clearly visible painted facial features, with limbs outstretched in an indeterminate pose, seemingly less skilfully carved than the others of the group (see fig. 5.10). There is also the aforementioned carving that does not closely resemble any single animal encountered in the natural world (see figs 5.3–5.5), but rather many, with its small, fin-like appendages, and a bulbous protrusion that may conform to a sea spirit type. Taken together these various carvings speak not just to a way of life, but to that life itself.

The carved igloo (see figs 5.8 and 5.9), or snow house, is a perfect replica of the structures built during the winter hunt to shelter Inuit within the ice and snow that made up this seasonal landscape.[14] It is constructed complete with an entrance porch, or storage area, that would further protect the inside space of the igloo from the icy winds and freezing temperatures outside. There is a window cut into the wall above the entrance, that, in life, would most usually be set with a piece of sea ice or thin animal skin, lending, in the case of the former, a tinted, underwater light to the interior that set it apart from other built spaces.[15] There is also a raised, fur-covered sleeping platform that would protect the inhabitants of the igloo from the snow floor beneath (see fig. 5.11). Finally, there are the carved forms of the family, placed at the centre of the structure.

The igloo, as with the architectural original, is etched with a spiral pattern replicating the painstakingly offset blocks that form the walls of the structure, ending with a complex swirl that echoes and replicates the bricks of ice leading to the keystone that would secure the roof of the original structure. An ingenious piece of structural engineering in its own right, the domed form of the igloo, with its centralised spiral, seems to echo the wider cosmological constants found in natural patterns, such as the often-cited examples of shell- and plant-forms conforming to the Fibonacci series.

Here, though, as we have already had cause to note, the tiny house is more than a micro-representation of Inuit architecture seen from outside. It is hinged, and so capable of revealing the inside of this Arctic dwelling, and the seven figures that inhabit it – at once presenting the inside and outside of the Inuit world.[16] The figures populating the igloo are carved in ranging sizes, suggesting a family, who crawl and sit as they inhabit the space, able to be placed in different relationships, both to each

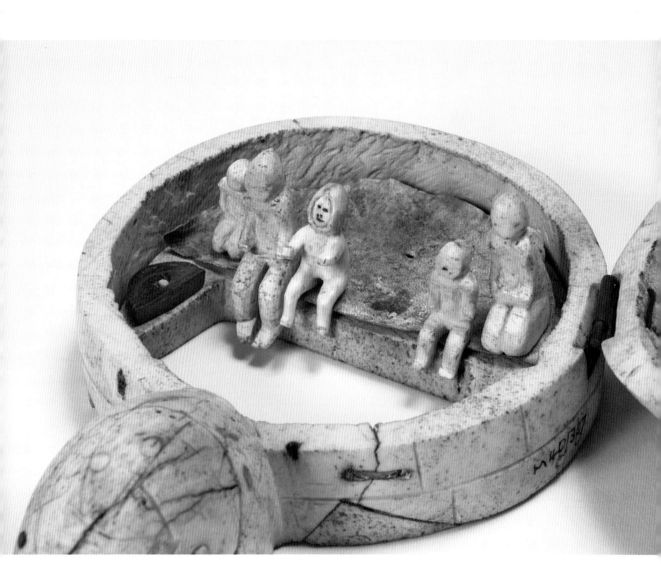

other and to the igloo. They are mobile, physically and conceptually, carved separately from the igloo, with many cosily fitting on the wide sleeping platform that fills almost half of the interior space, and whose surface is carved in a way that evokes the materiality of the fur coverings found there. Only one of these figures retains painted facial features today, but several of them clearly wear traditional Inuit hooded parkas, and their poses are lively, suggesting animation and movement. These are figures inhabiting a world – a tiny diorama of a living original – demarcated by the structure of the igloo, and moreover, by the negative space outside that is reminiscent of the vast expanse of Arctic ice and the space that once formed the backdrop of the original models.

The official catalogue designation of these carvings as a kind of 'toy' is interesting when applied to these works. It is tempting to see this small structure as akin to Western miniatures – model or toy houses – but the figures of this carved group are somehow more than mere toys. Moreover, it is also important to acknowledge that it is unclear if these carvings were intended to be taken as a group from the time of their making, and indeed, the variety of material used across the sculptures in this set may suggest otherwise, as might the fact that the carvings of the kayak and the bear match other Inuit forms thought to be commonly used as charms and amulets by hunters.

Fig. 5.11 Detail of Inuit carved igloo, interior. Carved from whalebone in Coronation Inlet, Hudson Bay, in the early 19th century, now displayed in the Hull Maritime Museum. © Hull Maritime Museum (2007.1397 05)

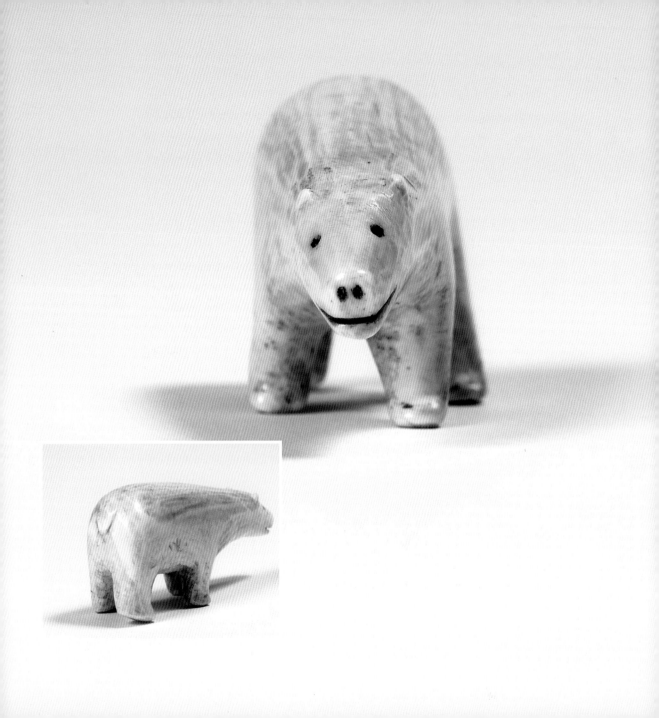

However, regardless of original intention, for twenty-first-century, first-world viewers seeing these carvings in a museum context it is hard to imagine them as anything other than a group. The bear, with its sleek solidity and alert ears, poised on stepping paws (see figs 5.12 and 5.13); the swimming duck with curious, outstretched head and beak; the kayak that rests outside the igloo, and even the two anonymous forms that may refer more to the spirit world of dreams than the everyday world of Inuit life; all of these, seen alongside the igloo, present the idea of a fully realised world in miniature. Here is the hunter, here his home; here the tools of his trade, here the animals that form such a delicate balance in his world. Here, possibly, are representations of some of the spirits that guide him, and here, in the captured forms of the carved objects, are the results of his way of life – both in the raw animal materials of whalebone and walrus tusk used to make these objects, and also powerfully present in the carved fur coverings, derived from the long hours of immersion, observation and hunting that resulted in these finely wrought sculpted objects. As such the designation 'toys' doesn't seem quite enough or quite right, since, understood as such, we lose a sense of the way that these carvings allude, in some quite precise ways, to Arctic place and identity, and to a history of Inuit making and meaning, as well as to their subsequent acquisition and transport to England.

Fig. 5.12 (inset) Inuit carved figure of a bear. Carved in Coronation Inlet, Hudson Bay, in the early 19th century, now displayed in the Hull Maritime Museum. © Hull Maritime Museum (2007.1399 01)

Fig. 5.13 Inuit carved figure of a bear. Carved in Coronation Inlet, Hudson Bay, in the early 19th century, now displayed in the Hull Maritime Museum. © Hull Maritime Museum (2007.1399)

Place, then, forms a crucial part of these sculptures, caught in both their raw material and fashioned forms, lending the voices of the Arctic and its peoples to the stories of the whalers and sailors celebrated in the Maritime Museum.[17] However, the idea of place is not the only idea that must be considered when thinking about these works from our critically informed, post-colonial vantage point. In the museum, they are displayed in a case of Inuit artefacts, including wooden carvings of seals and a goose, dolls, knives, bladder buoys, tools, and a kayak, which itself contains a representation of an Inuit man. As mentioned in the introduction to this volume, several of these artefacts came from moments of direct human exchange, many of them troubling, between Inuit visitors and Hull inhabitants. These include the ill-fated visit in 1847–48 of Memiaduluk and Uckaluk, two teenaged Inuit from Nyatlick, who were brought to England to be displayed as 'specimen[s] … of the far North'. Edwards notes that, today, the museum presents a haunting encounter with them, embodied, as they are, in a pair of plaster busts, cast from life shortly before Uckaluk's untimely death on her journey home to Canada – a death caused by contact with European society. Another kayak in the collection was tragically acquired by the Museum of the Literary and Philosophical Society after the drowning of an Inuk in a nautical display during his visit to the city in 1850, another poignant echo of a fatal cross-cultural encounter, now displayed in the collection as a historical artefact.[18]

Happily, these were not the only such instances of travellers moving between the Canadian Arctic, Greenland and the north-east coast of England. Several Inuit visitors brought artefacts with them that later ended up in collections such as Hull's, giving 'an [important] Inuit perspective on the era of whaling and exploration' as opposed to the 'Qullunaat (white person's) histories' that still dominate this subject.[19] This biased and

patchy construction of history surrounding the Arctic and its peoples is not new. Arctic historian Robert David notes that, even in the nineteenth century, the Arctic 'did not inspire the same level of academic study' that imperial scholar Edward W. Said has 'shown characterised the orientalists, with serious academic study of the Arctic postdat[ing] its nineteenth-century exploration'.[20] Part of the importance of objects such as the carvings discussed here is that they provide access to this lost world, and these unheard voices, if we are willing to let them speak to us.

Strangely, given the personal narratives of some of these objects, many of them resulting in tragedy, the small carved igloo group remains perhaps one of the most poignant. After all, the microcosmic world so evocatively presented by this sculptural group articulates both place and non-place.[21] In making us think about the place of the Inuit in the nineteenth century, we must, today, acknowledge that it is a place that is largely gone. As a result, the igloo now represents a type of placelessness, as well as evoking a place. Inuit culture today is flourishing, but it has required a lengthy political stand against mid-twentieth-century government settlement schemes to maintain its identity, traditions and land. Art making is still alive in Inuit culture, and Inuit carvings and prints are world renowned for their aesthetic idiom, quality and dynamism; they are collected privately and by institutions alike. However, the world has changed, and that change has left its mark on Inuit society, which generally operates far from the ice-based nomadism represented by the nineteenth-century carvings preserved in Hull.

A further item from the collection that viscerally calls forth the Arctic world for viewers, albeit in a more direct and confrontational manner than the Inuit igloo group, comes from the museum's collection of scrimshaw, labelled as coming from St Michael, Alaska.[22] This pair of carved jawbones (see fig. 5.14), complete with teeth fastened in place

with metal pins, are identified as being from a beluga, or 'white whale' by Janet West and Arthur G. Credland in their book on the Maritime Museum's scrimshaw.[23] They go on to describe the carved whale jaws as 'decorated in the traditional Eskimo "old style", with hunters attacking walrus with float attached, fish, kayaks, igloos with lines for drying fish, and a fleet of umiaks, eskimo sea going boats'. They date the carving to 1860–75, after contact with Western whaling vessels, as jawbones were not traditional material for art making in pre-contact Alaska.[24] However, the vessels are unlikely to be members of the British Whaling Trade as they would not have been active in this part of the Arctic.

These carved jaws are extraordinary, presenting a scene that evokes the drama and precariousness of the hunt, showing it as an event encompassing the entire community, placed as it is between the edge of land and the beginning of an expanse of water. The jaws work as a pair, presenting two facets of the hunting scene that together form a cohesive whole. The lower jaw nominally positions 'land' at the narrow edge of the jaw, closest to the protrusions of the teeth where a series of igloos are built, forming a village, awaiting the return of the hunters, optimistically rigged with lines and frames to preserve the animals and fish caught. To the side of this empty, waiting village are a group of kayaks and umiaks, afloat on the sea, full of hunters. Positioned towards the wider edge of the lower jaw, these boats are returning to the village, the central boat containing a figure posed with arms aloft. Given the scene carved on the upper jaw, and the nature of jawbones as a hinged pair, it is possible to interpret this lower jaw and upraised gesture as one of triumph, following the frenzied hunt shown on the jaw above.

The upper jawbone shows the hunt itself, but here the spatial relationship between the land and the sea is partially reversed. Here the temporary structures of igloo-like shelters and the alert, trotting form of a quadruped are poised at the broad edge of the

bone, while, just beyond, the fictive edge of the ice abruptly gives way to a watery environment teeming with life. Kayaks move urgently amid animal forms: walrus, fish, birds, seals and whales are all here. Some are emerging from the water, only the uppermost parts of their bodies visible above the waterline. Some are swimming under it – shadowy, abrupt forms viewed from above. Some are also flying above it, whilst some, pierced by the tools of the hunters, are dragged to the surface and held there by sealskin buoyant weights. Towards the teeth, the shifting relationship between land and water that shapes the Alaskan Arctic is demonstrated as the land begins again, and a seal turns towards the running form of a hunter, headlong into pursuit.

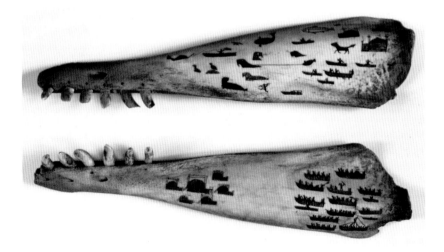

Fig. 5.14 Scrimshaw, pair of carved beluga jawbones with a hunting scene. Carved in St Michael, Alaska, dated to 1860–75, now displayed in the Hull Maritime Museum. © Hull Maritime Museum (2016.114.1-2)

Carved on a surface that was once part of a living animal found in this environment, an object of the hunting culture depicted here, these paired scrimshaw scenes work in tandem, telling the story of hunt and return, frenzy and aftermath. The shape of the jaws lends an additional meaning to the scene. Once a biting, consuming part of this ecology, the dislocated jaws, unhinged from their original function, are transformed into a cohesive whole by the narrative that transverses their space. The negative space of the whale's mouth adds an undercurrent of tension to the scene; the protrusions of teeth from the jaw, complete with their jagged whiteness, conjure unmistakable echoes of danger – both danger to the hunters, but also to the cetacean animal, which was so frequently depicted with its mouth vocally open in pain and exhaustion towards its death at the end of the hunt, as seen in the other images and histories discussed in the essays in this catalogue. The negative space of the jaw, with its slanted shape, also lends itself to the construction of a temporal reading of the scene – from hunt, to return, moving along the curved space of top and bottom – bringing the jaws back together as a whole, and so setting off again on a new hunt, reminding us that such scenes were necessary for survival in such a landscape, but also not letting us forget that the survival of one species often comes at the cost of another.

Place, space and non-place; ice and water; realistic image, recorded event and imagined as well as vanishing worlds; art, identity, object, animal, history, memory – the Inuit group in the Hull Maritime Museum collection is, in some ways, a memorial to its own making, as is the pair of Alaskan carved jawbones which present a complete scene of life and coastland, as well as being a potent reminder of the unavoidable centrality, harsh and strange beauty of the various types of predation and hunting so integral to life in this landscape.

Such carvings bear witness to the peoples and the cultures that produced and received them, as well as to the animals who died in order to provide the raw material used to make them. Held in the igloo, surrounded by displays housing the tools and creatures that shaped their world, and the skeletons and taxidermied animals that they hunted and that sought to hunt them, these so-called 'toys' stand as carved Inuit forms that continue to provoke as much fascination today as they did 200 years ago for the whalers who encountered them among the ice.

ENDNOTES

1 This attribution dates to the collection belonging to the Town Docks Museum, as is noted on the museum postcard showing this group of carvings and the interior of the igloo.
 The information on the postcard uses the term 'Eskimo', which has largely fallen out of favour in current discussion of this culture – although it is prevalent in early ethnographic studies. The term is still used in the US as the Aleut people do not consider themselves Inuit, but, when considering the peoples of the Canadian Arctic, the peoples largely under discussion here, Inuit is the preferred term, as demonstrated in the current object labels given to the collection of the Maritime Museum.

2 The bear and the kayak are both carved from walrus ivory.

3 This figure looks very like the iconographic type of the sea spirit suggested in the publication on Canadian Eskimo Art published by the Canadian Government's Department of Northern Affairs and National Resources in 1956. For a comparative image, see James A. Houston, *Canadian Eskimo Art* (Ottawa: Edmond Cloutier, 1956), 6.

4 For more, see Edward William Nelson, 'The Eskimo about Bering Strait' in *The Eighteenth Annual Report of the Bureau of American Ethnology*, 1896–97, Part 1 (Washington, D.C.: Government Printing Office), 1900; Dorothy Jean Ray, *Eskimo Art: Tradition and Innovation in North Alaska* (Seattle: University of Washington Press, 1977); Hans Himmelhaber, *Eskimo Artists* (Anchorage: University of Alaska Press, 1993); John F. Hoffecker, *A Prehistory of the North: Human Settlement of the Higher Latitudes* (New Brunswick: Rutgers University Press, 2005). See also William Fagg, *Eskimo Art in the British Museum* (London: British Museum, 1972); Norman Hurst, *Arctic Ivory: Two Thousand Years of Alaskan Eskimo Art and Artifacts* (Cambridge: Hurst Gallery, 1998), especially at 38; and Alma Houston, *Inuit Art: An Anthology* (Winnipeg: Watson & Dwyer, 1988).

5 Robert G. David, *The Arctic in the British Imagination, 1818–1914* (Manchester: Manchester University Press, 2000).

6 Ray, *Eskimo Art: Tradition and Innovation*, 5.

7 In case of linguistic confusion, it might be useful to note that 'Inuk' is the singular noun; 'Inuit' is the plural noun. The common translation of Inuit is 'the people'.

8 For more on shamanistic culture, and its accompanying objects, see Patricia Rieff Anawalt, *Shamanic Regalia in the Far North* (London: Thames and Hudson, 2014).

9 See n. 4, especially Fagg, *Eskimo Art*, 7. For further reading see Kaj Birket-Smith, *The Eskimos* (London: Methuen, 1959).

10 For further reading see Yi-Fu Tuan, *Space and Place: The Perspective of Experience* (Minneapolis: University of Minnesota Press, 1977), and Doreen Massey, *For Space* (London: SAGE, 2005).

11 See Houston, *Canadian Eskimo Art*, 7 and 16.

12 Houston, *Canadian Eskimo Art*, 33.

13 Houston, *Canadian Eskimo Art*, 31.

14 Ulli Steltzer, *Building an Igloo* (New York: Macmillan, 1981).

15 Steltzer, *Building an Igloo*.

16 For discussion of analogous use of space in visual material, see Robert Bruce Inverarity, *Art of the Northwest Coast Indians* (Berkeley: University of California Press, 1950), 35–52, especially at 37–38.

17 For more on this idea, see Dorothy Harley Eber, *When the Whalers Were Up North: Inuit Memories from the Eastern Arctic* (Boston: David R. Goodine, 1989).

18 David, *The Arctic in the British Imagination* (2000), 132.

19 David, *The Arctic in the British Imagination* (2000), 3.

20 David, *The Arctic in the British Imagination* (2000), 15–16. For Said's famous account, see Edward Said, *Orientalism* (New York: Pantheon, 1978).

21 For more on the idea of non-place, see Mark Augé, *Non-places: Introduction to an Anthropology of Supermodernity* (London: Verso, 2008).

22 This provenance is written on the back of one of the jawbones.

23 Janet West and Arthur G. Credland, *Scrimshaw: The Art of the Whaler* (Beverley: Hutton, 1995).

24 See Janet West and Arthur G. Credland, *Scrimshaw*, 44.